IMAGES
*of America*

# FORT ROSS
## AND THE
# SONOMA COAST

*Dedicated to the Sonoma North Coast, a place of Mediterranean climates and subduction zones, and to all who have made their homes here over the centuries.*

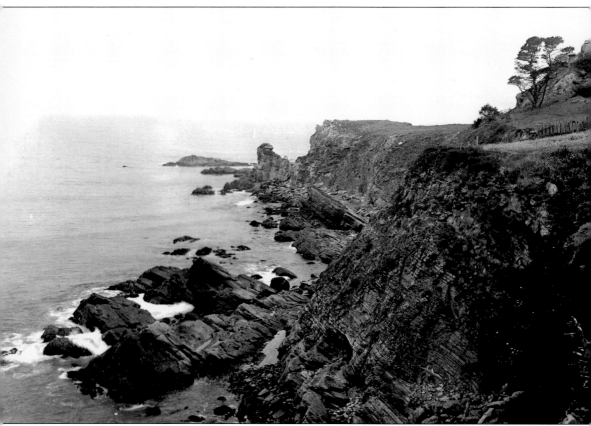

The Timber Cove coastline is shown here in 1912, looking much as it does today.

IMAGES
*of America*

# FORT ROSS
## AND THE
## SONOMA COAST

Lyn Kalani and Sarah Sweedler

ARCADIA
PUBLISHING

Published by Arcadia Publishing
Charleston, South Carolina

Printed in the United States of America

Library of Congress Catalog Card Number: 2004104603

For all general information contact Arcadia Publishing at:
Telephone 843-853-2070
Fax 843-853-0044
E-mail sales@arcadiapublishing.com
For customer service and orders:
Toll-Free 1-888-313-2665

Visit us on the Internet at www.arcadiapublishing.com

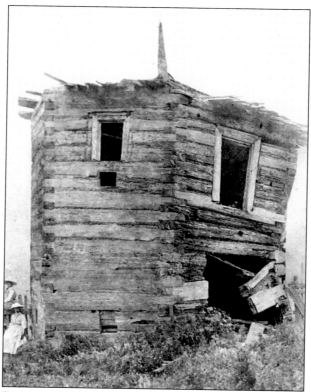

Emma and Mary Call stand beside the Russian Northwest
Blockhouse, c. 1900.

# CONTENTS

# ACKNOWLEDGMENTS

This small book of images draws extensively from the library and photographic archives at Fort Ross State Historic Park. It is our wish to illuminate the rich and varied history of California's North Coast by sharing the photographs in this collection. Except when credited otherwise, all photographs are from the Fort Ross archives. The support and encouragement of the staff of Fort Ross and Salt Point State Parks, and the Fort Ross Interpretive Association Board of Directors, has made this project possible. For those who would like more information about our resources and references, please contact us through the Fort Ross Interpretive Association at Fort Ross State Park, 19005 Coast Highway One, Jenner, California, 95450, or email us at fria@mcn.org.

The overview of Russian American history is built on the works of all those who have gone before us. The writing of this book would not have been possible without reference to the works of historians in Russia, Alaska, California, and beyond. John Middleton researched answers to our countless questions about things Russian-American. We soon discovered that in order to sketch the breadth of history found along the entire North Coast, we would need to reach out to the wider community. The Benitz family, especially Peter Benitz, sent us very early family pictures of Fort Ross. The Call family, especially Anna Hawkins and Rose Firestone, shared many family pictures, particularly the Mercedes Stafford collection. The Richardson family made a substantial contribution as well. We thank Arch Richardson for his historical insights, and Archer "Bus" Richardson, who sent us his family photo album via Ranger Ashford Wood of Salt Point. Ranger Michael Chiesa of Stillwater Cove Regional Park brought us photographs from the park's collection, and Ranger Karen Broderick of Salt Point contributed very early pictures of the area. David Skibbins of The Sea Ranch provided an important photograph with only a moment's notice. Longtime Jenner resident Elinor Twohy provided us a wealth of local lore as well as rare photographs. Seaview Ridge residents, especially Sarjan Holt and Susanna and Philip Barlow, provided help with contemporary images of the community. This book only touches upon the rich history of the North Coast, and we eagerly await the upcoming works of several local researchers, especially the detailed history of coastal residents currently being written by Lynn H. Rudy.

# INTRODUCTION
## The Legacy of a Russian Settlement in California

Americans are often surprised to learn that Russians once colonized a small stretch of California coastline. Russian settlers established Fort Ross in the early 1800s, during a time of unprecedented international expansionism.

At that time, California was claimed by many but occupied by few. The Spanish had been exploring Alta California since the 16th century, and established settlements as far north as the San Francisco Presidio, partially to deflect Russian expansion into the area. Northern California, however, had already been claimed by British explorers, beginning with Sir Francis Drake in 1579. Maps drawn as late as *Vancouver's Atlas* of 1801 show English claims that New Albion extended from Canada as far south as San Diego, although they occupied only a fraction of that land. News of the profitable sea otter trade, such as Captain Cook's report from Nootka Sound in 1778, brought ships—and more claims of entitlement—from all corners of the world. The first American ship to arrive in California was the *Otter*, which came in 1796 to hunt its namesake. Americans and Europeans were also working their way west across the North American continent.

Russia controlled parts of Alaska through a series of settlements administered by the Russian-American Company, a mercantile trading company protected by the tsarist government. The Russians had explored and charted part of the North Pacific during Bering's scientific expeditions between 1728 and 1742, and the lucrative fur seal and sea otter trade further solidified the Russian presence. Gregorii Shelikov and I.L. Golikov, like many of their fellow 18th century Russian merchants, ventured east of the Siberian mainland in pursuit of fur-bearing marine mammals. Recognizing the potential of the fur trade, the Golikov-Shelikov Company saw a larger business opportunity and in 1784 created a permanent settlement on Kodiak Island in what is now Alaska. Their company dominated the fiercely competitive fur trade and eventually, through the efforts of Shelikov's wife, Natalia, and son-in-law, N.P. Rezanov, became the Russian-American Company. In 1799, Tsar Paul granted the Russian-American Company a broad charter authorizing its monopoly over North America, including exploration, trade, and establishment of new settlements. By the early 1800s Russian settlements extended from the Aleutian Islands to their capital in New Archangel (present-day Sitka, Alaska). Over its history the Russian-American Company established settlements in the Kurile and Aleutian Islands, Alaska, California, and Hawaii.

Recognizing England's claim of discovery, and defying Spain's claim of sovereignty over Alta California, the Russian-American Company established Fort Ross in 1812 on an unoccupied stretch of coastal land 80 miles north of San Francisco. The Russians arrived, intent on growing food to ship to their Alaskan settlements, where the northern climate made farming difficult. For a time their profitable sea otter trade was also expanded, but because Russians, Spanish, English, and Americans all hunted sea otters for their valuable pelts, by the early 1820s the otter population was markedly diminished. The Russian-American Company established hunting moratoriums on both fur seal and sea otters in the North Pacific, the earliest known efforts at marine conservation. Ranching and a variety of small industries then fully occupied the colonial population.

For almost 30 years Russians inhabited the settlement at Fort Ross. The population included the Native Alaskans, California Native Kashaya, and Coast Miwok. A large part of the population was composed of Creoles, people of mixed Russian and native ancestry. The legacy left by the

Russians is vast. Russian colonists built the first windmills and ships in California. Explorers, scientists, and artists from Imperial Russia visited California and recorded their findings; their pioneering work in the region contributed information that is valuable to the present day.

In 1841 the Russians sold the Fort Ross assets to John Sutter, but he was not granted title to the land by the Mexican government. Sutter hired a succession of managers to dismantle and transport the remaining Russian possessions to Sutter's Fort in Sacramento. His last manager, William Benitz, moved his family to Fort Ross in 1846. Shortly thereafter California joined the Union. Benitz eventually purchased the land and turned the former Russian fort into a ranch which he operated successfully for over 20 years. Several owners followed Benitz, and during this period the Kashaya Indians who had lived on these lands for centuries were relocated to a reservation some 20 miles north. Then in 1873 George W. Call bought the property and established a ranching enterprise that endured for more than 100 years. During the Call era, Fort Ross was a vital social center for the surrounding communities, with an active port, post office, elementary school, hotel, and saloon.

From the mid-1800s until the early 1900s, population on the Sonoma North Coast was booming. Portions of the large Mexican land grants were sold. Ranches and mill settlements sprang up overnight, occasionally disappearing just as quickly as their owners moved on. In the early years, dog-hole schooners (so named because they could turn around in a cove barely large enough for a dog) braved the treacherous coastline to carry lumber and produce from these settlements to San Francisco. Towns boasted populations of several hundred, and had the requisite hotel, saloon, general store, blacksmith, school, and post office. But by the early 1900s, the land was logged and the hillsides overgrazed; without commodities to sell, the shipping industry declined. When the coast road connecting Jenner with Gualala was built in 1920, the era of dog-hole schooners was over.

In 1903, George W. Call sold the portion of his property which contained the Russian stockade, and in 1906 Fort Ross became a State Historic Park. The Russian fort, as well as the Rotchev House, the one remaining Russian-built structure within the compound, were eventually designated National Historic Landmarks. Almost a century of preservation, restoration, and reconstruction has helped to bring a small portion of the Russian settlement into the 21st century, but the six buildings seen in the fort today represent only a sample of the once rich and vibrant life at Settlement Ross. In addition to the fort, California State Parks now stewards some 3,000 acres of dramatic coastal land. Today the park is a focal point, attracting 150,000 visitors each year. Tourism, which began in the early days of the Fort Ross and Salt Point hotels, continues to flourish.

Unfortunately, preservation necessitates sacrifice; when the coastal bluff became parkland, residents had to move their community infrastructure northward and to the ridgeline above Fort Ross. Locals rebuilt their school and established a fire department on the nearby ridge, and now drive farther afield for the post office and other necessities. As during the ranching years, the community includes a vibrant group of residents living within a 20-mile area of Fort Ross extending from Jenner to Gualala and inland to Cazadero. Except for a handful of small towns, this stretch of the Sonoma North Coast hosts few people. It is wild, beautiful, and rich in history.

# One

# EARLY EXPLORATION
## RUSSIAN CONTRIBUTIONS
## TO LOCAL HISTORY

With its rocky shoreline and sheer cliffs, the Sonoma coast shows all the signs of a young continent at the leading edge of plate subduction. Fort Ross itself is built upon a large marine terrace, a remarkably flat bluff above vertical coastal cliffs of weathered sandstone and conglomerate rock.

For centuries the Kashaya lived upon these lands between the Gualala and Russian Rivers. They moved with the seasons, gathering acorns and hunting game in the coastal hills, then moving to the shoreline where they harvested abalone, mussels, fish, and various sea plants. The Kashaya's experience would begin to change during the 18th century, as numerous European countries explored, charted, and attempted to lay claim to California and the Pacific Northwest. Russian exploring expeditions and Russian-American Company officials were among the first to arrive and record the Native Californians, as well as the topography and natural curiosities of this area.

Amid the international uncertainty of the late 18th and early 19th centuries, the Russian-American Company decided to settle within California, building a colony to grow agricultural goods for shipment to their northern outposts. The Russians focused their southward expansion along the Sonoma coast—to the north of the Spanish settlements and within land the British claimed but did not occupy. And thus the Kashaya encountered their first Europeans.

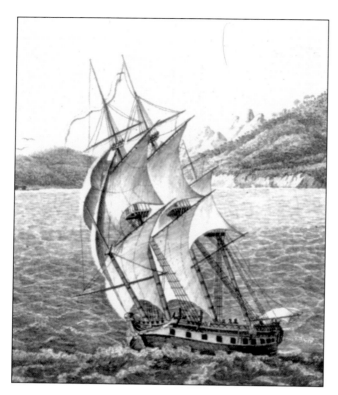

The *Nadezhda*, commanded by Captain Johann von Krusenstern, led Russia's first scientific circumnavigation (1803–1806). Expeditions such as these allowed explorers, scientists, recorders, and artists from Imperial Russia to contribute a legacy of information invaluable to the study of early California. They furthered the 1785 orders of Catherine the Great to undertake expeditions of scientific exploration "of the seas lying between the continent of Siberia and the opposite coast of America . . . to draw remarkable views of coasts . . . You are to enquire...about the...inhabitants of unknown places. . . Lastly, you are to procure or . . . to get painted, or describe . . . such nations." (Original engraving of the *Nadezhda* in the *Atlas* of I.A. Krusenstern, 1814.)

Nikolai Petrovich Rezanov participated in the voyage of the *Nadezhda* as an ambassador to Japan and director of the Russian-American Company. While in Japan he separated from the expedition, then traveled to inspect the Russian American colonies in Alaska, where he witnessed a "disastrous situation" of famine and suffering brought on by the cold climate and belated arrival of supply ships. Rezanov then organized a voyage to California. The trip resulted in his recommendation that the Russian-American Company establish a settlement in California's more hospitable climate to provide Alaska with agricultural products. (Courtesy of the Central Naval Museum, Saint Petersburg, Russia.)

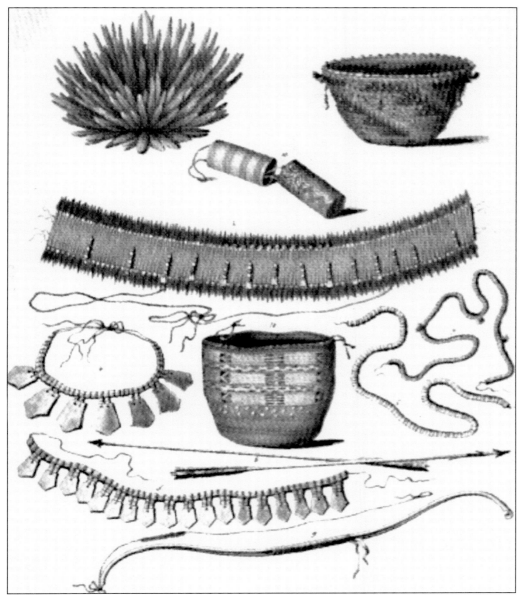

The physician and biologist Georg Heinrich von Langsdorff accompanied Rezanov to California in 1806. Langsdorff was a corresponding member of the Russian Imperial Academy of Sciences, and his memoirs present a classic account of early Spanish California. His sketches of California Indians and their artifacts enliven his journal and are among the earliest portraits of native life to have survived: "The bow has a pleasing form. It is made of wood, about three to four and one-half fuss long, finely worked. One side of it is skillfully covered with deer sinew that adheres very tightly to the wood. The arrows are just as finely and carefully worked . . ." (Illustration from Langsdorff's journal A *Voyage Around the World*, 1814.)

A. v. Chamisso.
Gez. v. E.T.A. Hoffmann. 805.

In 1816 Captain Otto von Kotzebue's voyage around the world on the Russian brig *Rurik* brought the naturalist Adelbert von Chamisso, the artist Louis Andreyevich Choris, and the entomologist-zoologist Johann Friedrich Eschscholtz to California, all of whom made lasting contributions to the study of early California. Russian scientists recorded and named many California plants and animals, including bull kelp (*Nereocystis lutkeana*), the yellow-faced bumble bee (*Bombus vosnesenskii*), and the Monterey salamander (*Ensatina eschscholtzi eschscholtzi*). Adelbert von Chamisso is pictured.

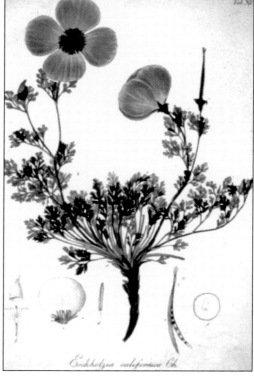

*Eschholzia californica Ch.*

During his stay in the San Francisco area in 1820, Chamisso collected and named the California poppy *Eschscholtzia californica*, after his colleague Johann Eschscholtz. The poppy is now California's state flower. (Original in New York Botanical Garden, The LuEsther T. Mertz Library.)

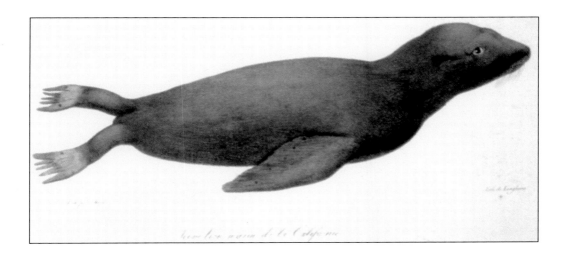

Russian artists were the first to record many California species, such as this California sea lion portrayed in 1816 by Louis Andreyevich Choris during the visit of the *Rurik*. While in San Francisco Choris also sketched this California grizzly, once a symbol of frontier California and a common sight along the coast. "Another excitement of the road was the danger of meeting grizzly bears, which at that time were very numerous," wrote Charles S. Greene in 1890 about traveling the road to Fort Ross. "There was one little barranca that the road skirted, where in the springtime it was not an uncommon thing to look down and see the backs of four or five grizzlies in the deep clover that they like to feed on in that season." The California grizzly is now extinct. (Original Choris sketches in *Voyage Pittoresque Autour du Monde*. Paris, 1822.)

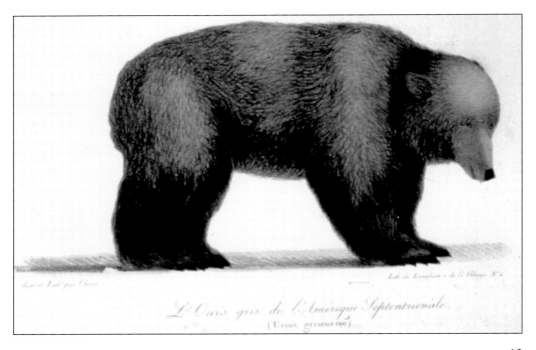

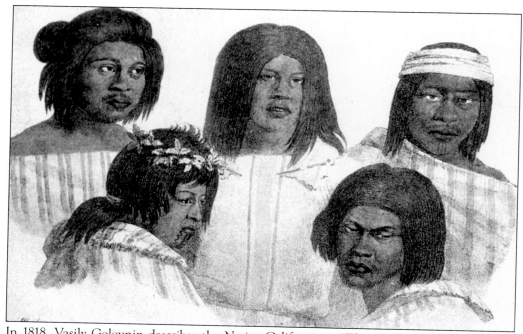

In 1818, Vasily Golovnin describes the Native Californians: "They do not bother to till the soil for food, but take advantage of the free gifts of nature . . . The most important plant food consumed by them are oak acorns, which grow in great abundance here. To harvest the rye grain they resort to a very simple, although rather curious, method: they set fire to the entire field; the grass and the stalks, being very dry, burn very fast, while the grain is not consumed by the fire but only scorched. Then the Indians collect the scorched grain and eat it without any further preparation . . . " This early portrayal of Native Californians from several tribes, above, and "Things of the Indians of California," below, are by Louis Choris, 1816. (Original in *Inhabitants of California* in *Voyage Pittoresque Autour du Monde*, Paris, 1822.)

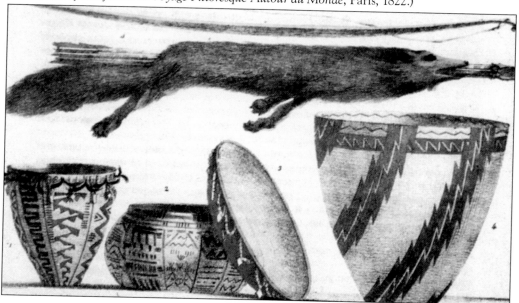

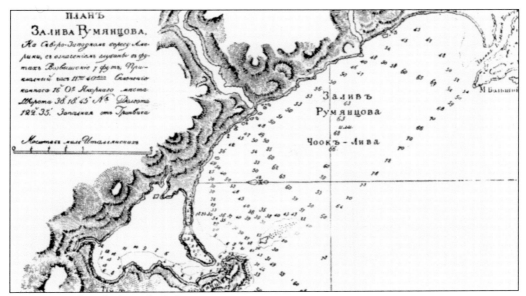

In 1818, Vasily Nikolaevich Golovnin, Russian Naval Captain of the *Kamchatka,* visited northern California, stopping at Fort Ross and Bodega Bay. His memoirs describe the warm welcome given him by the Miwok chiefs at Bodega Bay. Golovnin describes meeting Chief Valenila, who "wanted more Russians to settle among them in order to protect them from Spanish oppression. He begged me for a Russian flag, explaining that he wanted to raise it as a sign of friendship and peace whenever Russian ships should appear near the shore." Golovnin drew this map of Rumiantsev Bay (Bodega Bay) during his inspection of the colony in 1818.

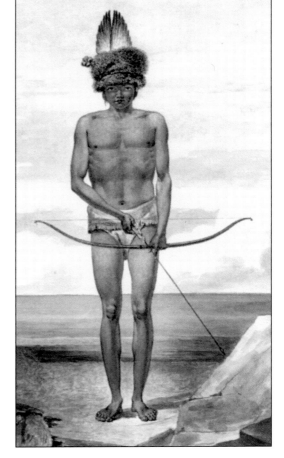

On board Captain Golovnin's ship was the young artist Mikhail Tikhonovich Tikhanov, who sketched California Indians while visiting Bodega Bay. Pictured here is *Balthasar, Inhabitant of Northern California.* (Original in the Scientific Research Museum of the Russian Academy of Fine Arts.)

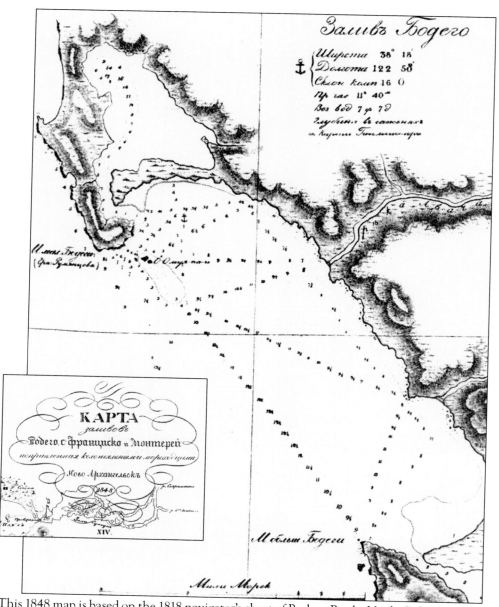

This 1848 map is based on the 1818 navigator's chart of Bodega Bay by Vasily Golovnin. It reverts to the Spanish name of Bodega Bay, but does give reference to its former use as a Russian port by mentioning the name Rumiantsev. (Detail of Bodega Bay from *Chart of the Bays of Bodega, San Francisco, and Monterey Corrected by Colonial Mariners, New Archangel,* from Captain Mikhail D. Tebenkov's Atlas, 1852.)

# Two

# FORT ROSS
## A RUSSIAN COLONY IN CALIFORNIA

Pictured is the seal of the Russian American Company.

The harsh northern climate made self-sufficiency impossible in the Russian-American Company's Alaskan settlements, and the company officials decided to establish an agricultural base in California to increase the food supply. Alexander Baranov, manager of the Russian-American Company, directed Ivan Kuskov, his chief deputy, to select a site north of Spanish claims at San Francisco Bay. Kuskov established a base at Bodega Bay on the Sonoma Coast, 60 miles north of San Francisco, which he named Port Rumiantsev. From there Kuskov explored the surrounding territory, and in 1811 he selected a location for the California settlement on a bluff above a sheltered cove 18 miles north of Bodega Bay. The site offered soil suitable for farming, as well as access to timber, water, and pasturage. It lacked the deep-water anchorage of Bodega's outer bay, but its relative inaccessibility from Spanish-occupied territory gave it an advantage in terms of defense. In March of 1812 Kuskov arrived at the site of Fort Ross with 25 Russians and 80 Native Alaskans, and immediately began building housing and a wooden stockade. The colony was named Fortress Ross, and was formally dedicated on August 13, 1812.

Internationally, 1812 was an eventful year; Spain, France, Russia, and other great colonial powers of the day were preoccupied with a major war, and Great Britain was at war with the United States. With San Francisco Bay marking the northern limit of the Spanish settlement, it was some time before the civil and military leaders of Spanish California became aware of the Russian settlement. The Russians negotiated with the Kashaya for use of the land and quietly started to create a self-sufficient colony along the Sonoma coast.

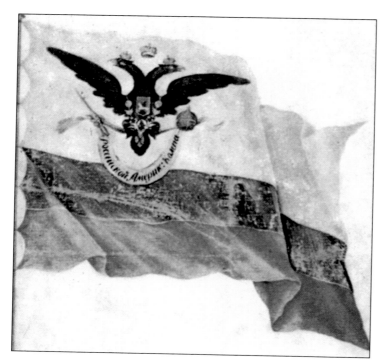

Chartered by the Russian government in 1799, the Russian-American Company was Russia's first commercial trading company protected by the crown, with a mandate to control all Russian exploration, trade, and settlement in North America. After 1800 the company's main office moved from Siberia to Saint Petersburg. Shareholders included high officials, court nobility, and members of the tsar's family. The emperor granted the Russian-American Company its own flag in 1806.

Alexander Andreyevich Baranov served the Russia-American Company from 1790 to 1818. Under his leadership as chief manager and governor, Russian influence expanded from the Aleutian Islands to northern California and Hawaii. The southward expansion, and the trade associated with it, was essential to the survival of the Russian settlements in Alaska. This image is an engraving after an oil by Mikhail T. Tikhanov, painted in 1818 just before Baranov's retirement at the age of 71.

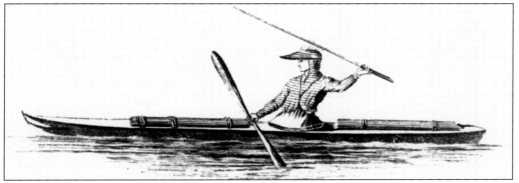

Highly skilled Aleuts excelled at hunting sea mammals from their *baidarkas*, the Russian word for their swift maneuverable kayaks. The Russians brought Native Alaskans to Fort Ross to hunt and work for the colony. Before 1820, the Aleuts were drafted into company service and paid according to the number of their catch. After 1820, they were designated company employees with guaranteed civil rights. The Aleuts were furnished with waterproof parkas and boots, as well as sea lion skins with which to repair their *baidarkas*. This is a detail from an engraving by Luka Vornonin, early 1790s. (Original in *Sarychev Atlas*, Saint Petersburg, 1826.)

This portrayal of a sea otter was drawn by John Webber on Captain James Cook's third voyage in *A Voyage to the Pacific Ocean*, an atlas published in London in 1778. It was Cook's report of the successful sale of otter skins in China which led to the "soft gold rush" in the Pacific Northwest. The otter population was quickly diminished, prompting the Russians to establish hunting moratoriums in the first half of the 19th century; the United States did not enact conservation measures until the early 20th century. Sea otters no longer live along the Sonoma Coast, but their populations have rebounded along California's central coast in the vicinity of Monterey Bay.

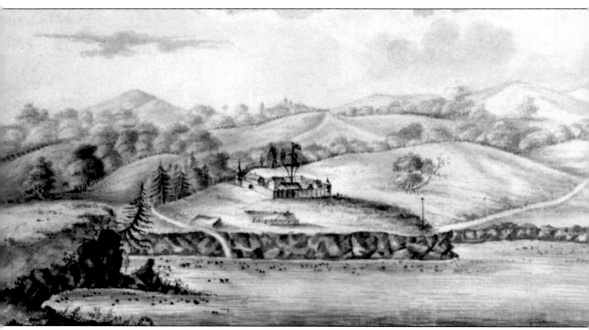

By 1817 the colonists had used local redwood to construct a Russian-style fort, which consisted of a stockade, blockhouses, and log buildings. This detail from the earliest-known painting of Fort Ross is from the *Plan of Fortress Ross* (1817). This map was sent to Madrid when the Spanish government demanded information from Saint Petersburg about the settlement. The Russians also sent a document asserting their legal right to occupy the land based on their agreement with the native population. (Original map in the State Naval Archive, Saint Petersburg, Russia.)

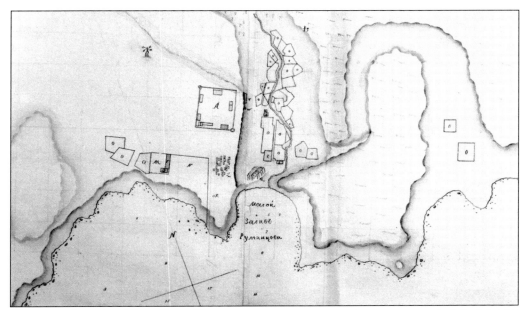

This map, also a detail from *Plan of Fortress Ross* (1817), refers to the settlement as *Krepost Ross*, Fortress Ross, and lists at least nine structures, a well, and a flagstaff within the fort compound. Outside the fort were "fourteen Aleut yurts," gardens, "of which there are fifty around fort," and cattle and sheep enclosures. In the cove below the fort the map lists yet more structures, as well as the brig *Rumiantsev*, the first ship built in California. (Courtesy of State Naval Archive, Saint Petersburg, Russia.)

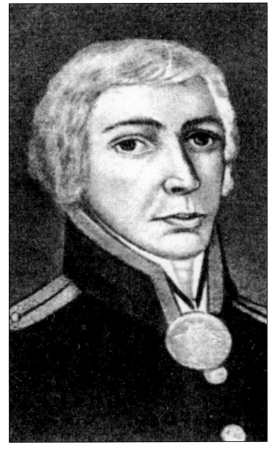

Ivan Alexandrovich Kuskov served the Russian-American Company for 22 years. He was the founder of Fort Ross, and served as its colonial administrator from 1812 to 1821. After leaving the Russian-American Company he returned to his native town of Tot'ma, Russia, where he died in 1823. Karl Ivanovich Schmidt replaced Kuskov as administrator from 1821 to 1824. Pavel Ivanovich Shelikhov was manager from 1825 to 1830; Peter Stepanovich Kostromitinov from 1830 to 1838; and Alexander Gavrilovich Rotchev was the last administrator, serving from 1838 to 1841. (Courtesy of Tot'ma Regional History Museum, Russia.)

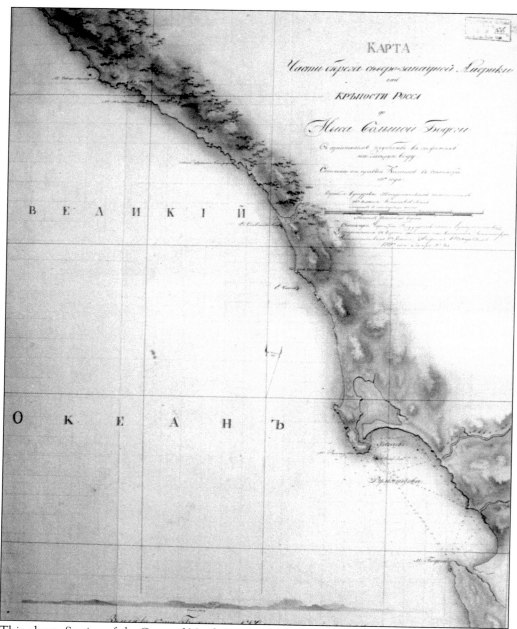

КАРТА

*Части берега северо-западной Америки*

*и*

КРѢПОСТИ РОССЪ

*и*

*Мыса большой Бодеги*

В Е Л И К І Ӥ

О К Е А Н Ъ

This chart, *Section of the Coast of Northwest America from Fortress Ross to Point Great Bodega 1817,* lists (from top to bottom) Point Northwest, Fortress Ross, Point Northwest West, Baidarka Refuge Harbor (Russian Gulch), Slavianka Gate Island (Russian River), Point Slavianka, Sea Gull Island, Point Rumiantsev, Rumiantsev Bay (Bodega Bay), and Great Bodega Point. Ivan M. Kislakovskii, the cartographer of this chart, was navigator on Captain Leontii Hagemeister's ship *Kutuzov.* It was on this trip that Kuskov, Hagemeister, Kislakovskii, and others conducted the treaty with the Kashaya, who leased the land of Fort Ross to the Russian-American Company. This was the only such agreement conducted between Europeans and Native Californians. (Courtesy of State Naval Archives, Saint Petersburg, Russia.)

# Three

# THE FORT ROSS SETTLEMENT
## 1812–1841

Russian Fort Ross was populated by an unusual blend of cultural groups—Russians, the Native Kashaya and Coast Miwok, and Native Alaskans. Much of the population was Creole, people of mixed Russian and native descent. Everyone in the vicinity of Fort Ross worked for the Russian-American Company. The settlement was headed by a manager who oversaw a broad range of daily activities. The Russian and Creole colonial population included administrative assistants, work supervisors, and artisans such as carpenters, blacksmiths, coopers, and shipwrights. There were many laborers and hunters in the company's service. Before 1820, workers were hired to work on a share-of-the-catch basis; after that time they were paid a salary, signing on for a seven-year term. Salary was paid in company scrip, out of which they had to buy their clothes and food.

Farming, hunting, ranching, and a wide variety of small industries filled the days, including an early example of selling prefabricated houses: "We went with Mr. Shelekhov to view his timber production. In addition to the needs of his own settlement he cuts a great quantity of planks, beams, timbers, and the like, which he sells in California, in the Sandwich Islands, and elsewhere; he even builds entire houses and ships them disassembled. The trees felled are almost all conifers of several kinds and especially the one called *palo colorado* (redwood)." [Duhaut-Cilly, *A Voyage to California*.]

But the colony proved unprofitable even with its diverse activities, and by 1839 officials of the Russian-American Company decided to abandon Ross. The causes were numerous. Sea mammal hunting had not been lucrative for many years. The Russian agricultural efforts were foiled by cool coastal weather and an abundance of pests, and in 1839 Russia successfully signed a treaty with England's Hudson Bay Company to supply Alaska with grain and meat, thus eliminating the necessity for the California settlement. Pressures also existed externally, with new settlers flowing into the region. These new residents challenged the Russian claims over territory. In April 1839, the tsar approved the company's plan to liquidate the settlement, and shortly thereafter the company offered all of its California holdings for sale.

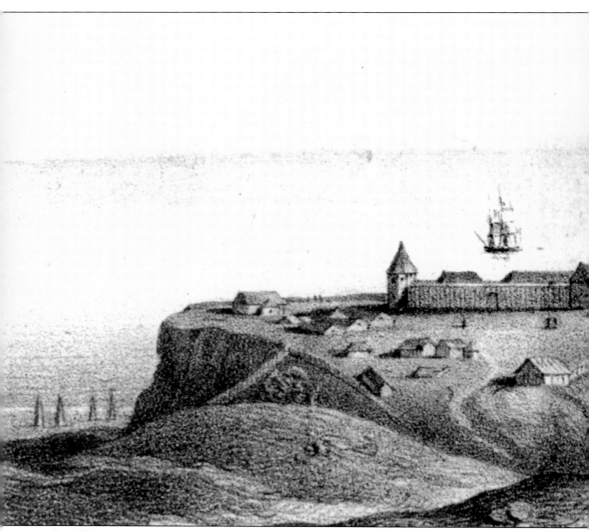

In 1832 an anonymous Bostonian who visited Ross describes the stockade and manager's residence: "The Presidio is formed by the houses fronting inwards, making a large square, surrounded by a high fence. The Governor's house stands at the head, and the remainder of the square is formed by the chapel, magazin, and dwelling houses. The buildings are from 15 to 20 feet high, built of large timbers, and have a weather-beaten appearance." Only the higher-

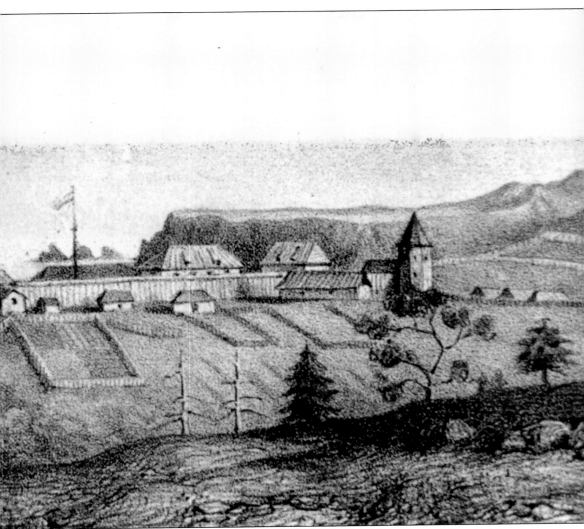

ranking Russian officials and visitors lived inside; most of the Russian and Creole Company employees lived in the village complex of houses and gardens west of the stockade walls. The Native Alaskan workforce and their families, often including Kashaya and Coast Miwok women, lived in another village south of the stockade wall on the marine terrace. (*View of Fort Ross, 1828*, by A.B. Duhaut-Cilly.)

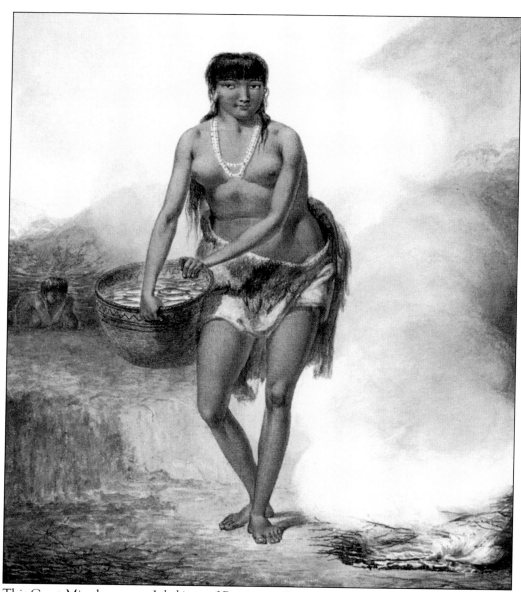

This Coast Miwok woman, *Inhabitant of Rumiantsev Bay*, was painted by Mikhail Tikhonovich Tikhanov in Bodega Bay in 1818. Many Coast Miwok appear on the records of the inhabitants of Settlement Ross. Fort Ross Manager Kostromitinov describes: " . . . The physiognomy of the Indians in general bears the impression of good nature rather than savagery, and one often sees charming faces, among males as well as females. They are placid, peaceful and very capable . . . The men go completely naked; the women cover the middle part of the body . . . with the skins of wild goats . . . The Indians who live closer to Ross and often work there have jackets, trousers, blankets and other things which however they regard with complete unconcern. If they obtain something of this sort, they gamble it away . . . it is sometimes comical to see a savage dressed in a woman's gown with a chemise over it, or another wearing all the shirts he owns, so that he can hardly move . . ." (Original painting in the Scientific Research Museum, Russian Academy of Fine Arts.)

This portrait of a Creole at Fort Ross was drawn by I.G. Voznesenskii in 1841. The settlement's population varied over the years. In 1836, Ioann Veniaminov reported: "Fort Ross contains 260 people: 154 male and 106 female. There are 120 Russians, 51 Creoles, 50 Kodiak Aleuts, and 39 baptized Indians." The women were typically Creole, Native Alaskan, or Native Californian.

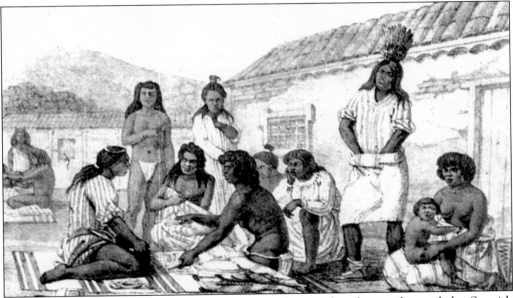

The inhabitants of Fort Ross did not live in isolation. Russian ships frequently traveled to Spanish ports, and there was extensive trade with Spanish, and later Mexican, California, as well as Britain, the United States, Chile, Europe, and China. Madrid forbade trade and demanded that the Russian colony be removed, but the Spanish colonists were eager to buy Russian goods, and trade between Ross and the Spanish colonists flourished despite the ban. Farm implements and boats were sold and traded to the Spanish for food grown in the Missions, which was shipped by the Russians to Alaska. After Mexican independence in 1821, the Russians provided military goods to the Mexicans. *Indians Gambling at Mission San Francisco de Asis* was painted by Louis Choris when the *Rurik* visited San Francisco in 1816. (Original in *Inhabitants of California* in *Voyage Pittoresque Autour du Monde*, Paris, 1822.)

This detail from *Settlement Ross, 1841*, shows the first Russian Orthodox chapel in North America outside of Alaska, which was built in the mid-1820s. The settlement had no resident priest, but in 1836 Father Ioann Veniaminov visited Fort Ross and conducted marriages, baptisms, and other religious services. Father Veniaminov, an active missionary among the Native Alaskan people, became bishop of Alaska and senior bishop of the Russian Empire. He was eventually named Saint Innocent.

*Settlement Ross, 1841,* is portrayed here by Russian naturalist and artist Ilya Gavrilovich Voznesenskii. In 1841 the inventory for John Sutter lists buildings outside the fort: "twenty-four planked dwellings with glazed windows, a floor and a ceiling; each had a garden. There were eight sheds, eight bath houses and ten kitchens." Outside the stockade were two windmills, cattle yards, bakery, threshing floor, cemetery, farm buildings, bath houses, vegetable gardens, and an orchard. At Sandy Beach Cove there was a forge and blacksmith shop, tannery, cooperage, public bath, and a boat shop and shipways for building ships. (Courtesy of Peter the Great Museum of Anthropology and Ethnography, Russian Academy of Science, Kunstkamera, Saint Petersburg, Russia.)

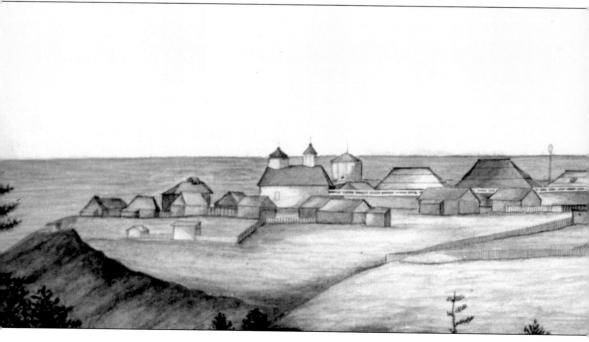

Voznesenskii's drawing shows California's earliest windmill. One blade is visible on the tower at the right. By 1841 Fort Ross had two windmills, the first to be built in California. Although agriculture was the cornerstone of Fort Ross's establishment, production never met expectations. In an attempt to intensify production, the company eventually established three farms at inland sites between Fort Ross and *Port Rumiantsev* (Bodega Bay).

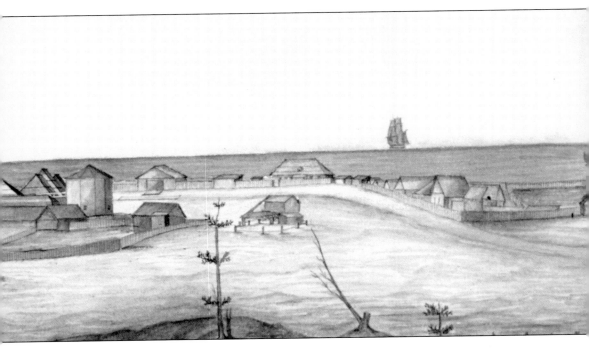

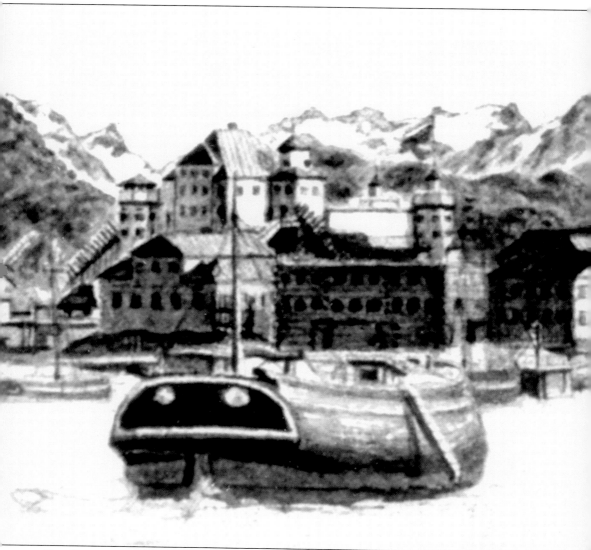

Four Russian-American Company ships—three brigs and a schooner—were the first ships built on the California coast. Built between 1817 and 1825, these vessels were seaworthy for approximately five years in the harsh conditions of the North Pacific. Finding California hardwoods unsuitable for ship building, the Russian-American Company abandoned shipbuilding at Ross by 1825, but did continue building smaller boats. The *Buldakov*, built at Fort Ross, is pictured in this detail from *Unfinished Watercolor of Novo-Arkhangel'sk (Sitka) Harbor* by Pavel Mikhailov, 1827. At the time this picture was painted, the *Buldakov* was serving as a storehouse in the Alaskan harbor. (Courtesy of State Russian Museum, Saint Petersburg.)

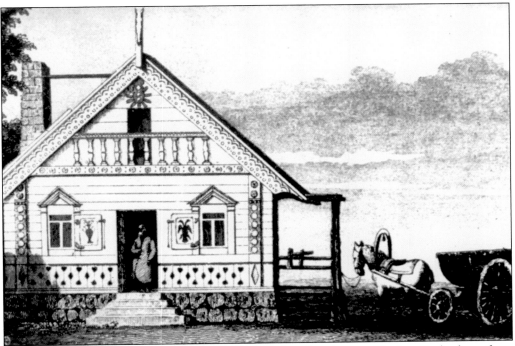

Fort Ross's main port was 18 miles to the south at Port Rumiantsev (Bodega Bay) where there was a deep-water anchorage and wharf. Ships from various countries stopped at the port to trade with the Russians. In addition to a storehouse and housing, there was a permanently-stationed 25-ton "copper-covered smallboat, well suited for navigating all along the coast of California." The goods were then transported from Port Rumiantsev to Fort Ross's Sandy Beach Cove using Russian launches, Native Alaskan *baidarkas* (kayaks), and *baidaras* (large, open-skin boats that carry cargo and up to 15 passengers). Eugene Duflot de Mofras, French attache to Mexico, stopped at Rumiantsev in 1840 and drew this picture of a Russian house indicating that "such structures were found at outlying farms of the Russian colony." Below, the Chernykh Ranch, inland from the present Bodega, was one of three ranches established to supplement Fort Ross's agricultural efforts.

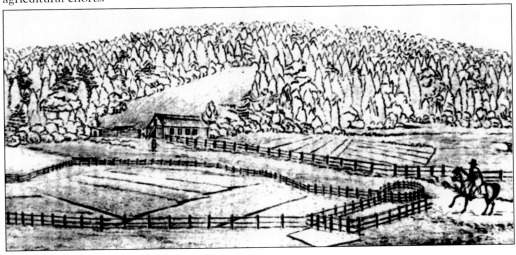

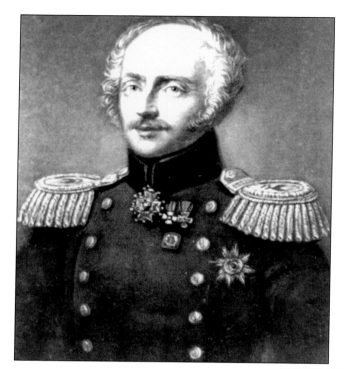

In 1836 Baron Ferdinand Petrovich von Wrangell, manager-in-chief of the Russian-American Company, made a final effort to avert Russian withdrawal from Fort Ross by traveling to Mexico City to seek improved relations with the Mexican Republic. He sought Mexico's formal recognition of the legality of Russia's claim to Fort Ross. The Mexicans were willing to yield on this issue, but only in return for Russia's diplomatic recognition of their own national independence as a republic. Tsar Nicholas I rejected the condition. (Courtesy of the Central Naval Museum, Saint Petersburg.)

Naturalist and artist Ilya Voznesenskii was sent by the Russian Imperial Academy of Sciences to explore and investigate Russian America. In 1840 he spent a year in California collecting specimens of flora, fauna, and Native Californian artifacts. Many of these objects are the sole surviving items of their kind, and Voznesenskii is seen as Russian America's greatest collector. His invaluable ethnographic collection is now on display in the Peter the Great Kunstkamera Museum in Saint Petersburg Russia. This is a Northern Californian ceremonial basket collected by Voznesenskii in 1840. (Courtesy of Kunstkamera Russian Academy of Sciences, Saint Petersburg.)

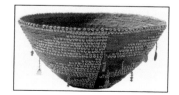

Alexander Rotchev was the last manager at Fort Ross. He was an intelligent and well-traveled person, accomplished in the arts and conversant in several languages; his wife was a member of Russia's titled nobility. Their home, shared with their children, was constructed c. 1836, and is the only remaining Russian-built structure at Fort Ross. A French visitor remarked that the Rotchev's possessed a "choice library, a piano, and a score of Mozart." By 1841, Rotchev was ordered to sell the settlement. He approached both the Mexican government and the Hudson Bay Company, but neither party wanted to purchase the fort. In 1841, he successfully negotiated the sale to John Sutter of New Helvetia, in what is now Sacramento.

John Sutter agreed to pay the Russian-American Company the equivalent of $30,000 in installments of wheat over a three-year period for the livestock, equipment, and armaments at Fort Ross, which he then moved to his own settlement. The sale did not include the land. A Swedish visitor, G.M. Waseurtz of Sandel, drew this view of Fort Ross during his visit in 1843, shortly after the Russians departed. (Illustration from *A Sojourn in California by the King's Orphan*, 1945.)

# *Four*

# FROM RUSSIANS TO RANCHERS
## 1840s–1870s

In September of 1841, John Augustus Sutter signed an agreement with the Russian-American Company to purchase the assets of Fort Ross. Sutter made the purchase on credit and proceeded to move everything that could be moved to his land near current-day Sacramento. Sutter never lived at Fort Ross, but hired a succession of managers to oversee its dismantling. One such manager was John Bidwell: " . . . Sutter bought them out—cattle and horses; a little vessel of about twenty-five tons burden, called a launch; and other property, including forty odd pieces of old rusty cannon and one or two small brass pieces . . . This ordnance Sutter conveyed up the Sacramento River on the launch to his colony." The Mexican authorities officially rejected Sutter's claim of land ownership, instead dividing it into two holdings: the Bodega Rancho, between Bodega Bay and the Russian River, granted to Captain Stephen Smith, and the Muniz Rancho, between the Russian River and Timber Cove, awarded to Manuel Torres, whose sister was married to Captain Smith.

The last manager under Sutter was William Benitz, who eventually leased the land from Sutter. Benitz later purchased the Muniz Rancho, including Fort Ross. He successfully planted a broad range of crops, and raised cattle, sheep, and horses, creating a self-contained agricultural empire which brought stability to the coast.

Benitz left Fort Ross in 1867, selling off his land in two large parcels. The northern half, including the fort, was sold to James Dixon, a sawmill operator in Marin County. The southern portion went to Charles Snowden Fairfax. Neither Dixon nor Fairfax intended to live on the land. They purchased the property intent on recouping their investment through lumber sales, and held the parcels only long enough to harvest the most accessible timber.

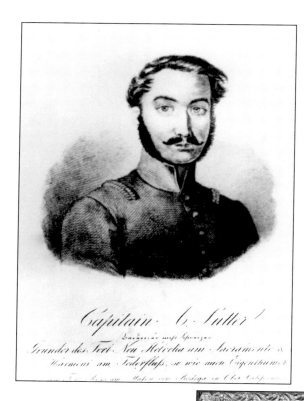

*Capitain G. Sutler*
*Gründer des Fort Neu Helvetia am Sacramento &*
*Harmoni am Federfluss, so wie auch Eigenthümer*
*Fort Ross am Hafen von Bodega in Ober Californien*

In September of 1841, John Augustus Sutter, whose name later became synonymous with the discovery of gold, bought the assets of Fort Ross on credit. He spent many years paying off this debt. Sutter never lived at Fort Ross, but worked quickly to move the Russian's belongings to Sutter's Fort in Sacramento.

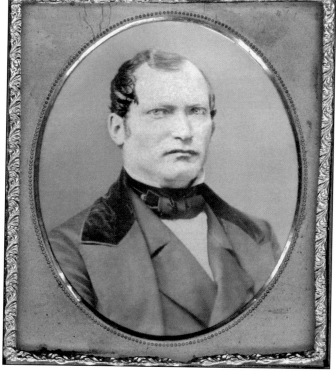

William Benitz wrote on March 14, 1852, "Dear Brother and Sister, . . . I'm living here in California, since the year 1842. Thank God, I am doing very well. I am married, got a son of 2 years, and 3 babies died. My wife is from Endingen, the daughter of little Michael Kolmer and Josephine Wagner . . . I have a partner, a German. We have . . . about 1000 head of cattle, 200 mares, and horses. We also plant a lot and have done well. Our work is all done by Indians, of which we have about 100 families. The place where I'm living for 9 years already is called Fort Ross . . . Now we have transformed this place into a farm." (Courtesy of the Benitz family.)

William Benitz married 17-year-old Josephine Kolmer shortly after she arrived with her family in Sonoma in 1845 as part of the John Grigsby/ William B. Ide wagon train. Benitz gave the Kolmer family land at Timber Cove, which their descendants kept for 100 years; Kolmer Gulch is named for them. (Courtesy of the Benitz family.)

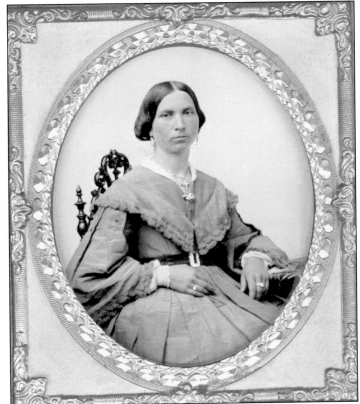

Josephine bore 10 children while living at Fort Ross; 7 survived to adulthood. This is Fort Ross c. 1866 when it was the Benitz family ranch. (Courtesy of the Benitz family.)

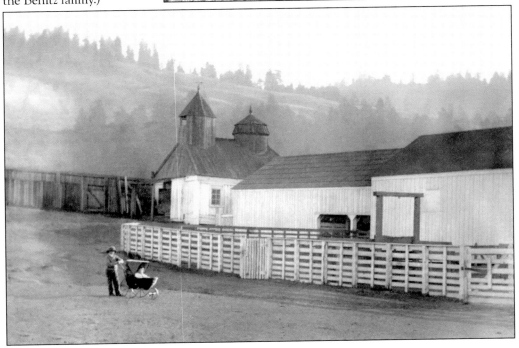

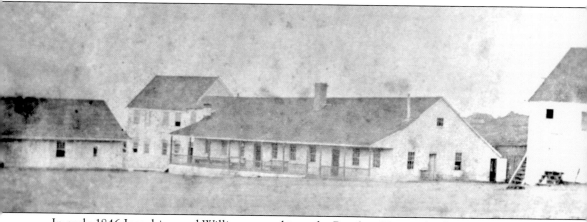

In early 1846 Josephine and William moved into the Rotchev House. As the family grew, Benitz expanded the Rotchev House (center) and built the two-story addition which stood until 1926.

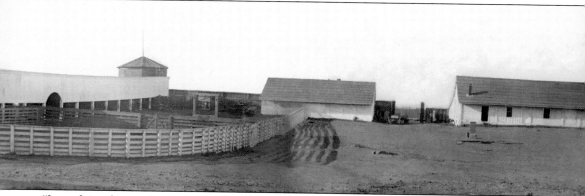

"I am doing better than most of the farmers, many of which made debts in the bad times and went bankrupt, while I have built up a lot in spite of the crisis. I've had to replace many of the old Russian houses with new ones, and this task will keep me busy during next year too. Besides I will have to renew my mill, which has worked for the last 12 years . . ." September 22, 1856, William Benitz. These photographs, the earliest of Fort Ross, were taken c. 1866 during the Benitz era. (Courtesy of the Benitz family.)

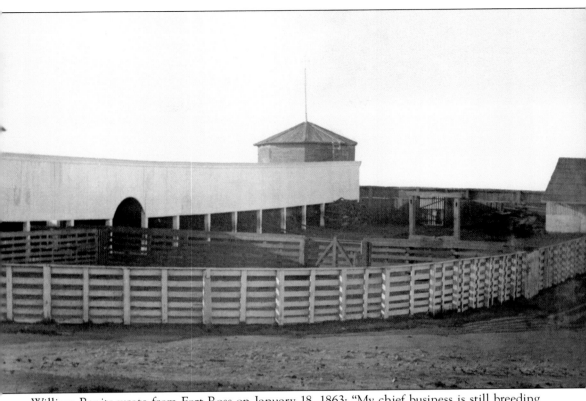

William Benitz wrote from Fort Ross on January 18, 1863: "My chief business is still breeding cattle and horses. Last winter we had a lot of cold and wet weather. The flat parts of the countryside have all been overflowed, and hundreds of houses were washed away, cattle, horses, etc. got drowned and many people went bankrupt. I've also lost 200 head of cattle and 30 horses through hunger and cold." (Courtesy of the Benitz family.)

By the time this picture was taken in 1866, restoration of the Fort Ross warehouse (left) had greatly modified its Russian appearance. It was described in the 1841 inventory as "The old warehouse, two stories, built of beams . . . surrounded by an open gallery with pillars." Benitz is said to have used it as a hay barn. At that time it was joined by vertical siding with the "new" Russian warehouse. It survived long into the ranch era, and was not torn down until the 1920s. (Courtesy of the Benitz family.)

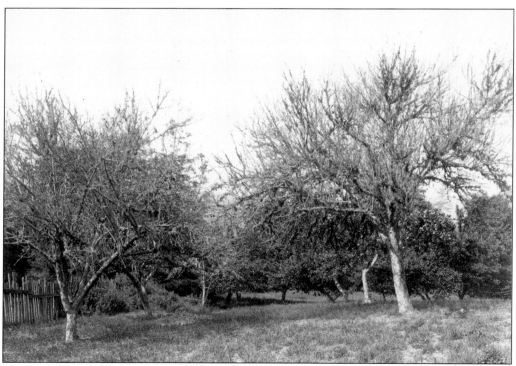

The Russians planted an orchard on the hillside north of the fort, and by 1841 there were 260 fruit trees—apples, peaches, pears, quince, and cherries. Benitz expanded the orchard by planting another 1,700 trees.

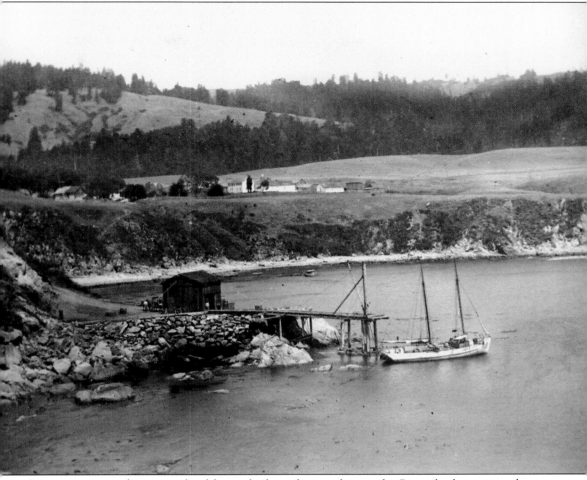

Benitz constructed a stone wharf from which to ship out his goods. Coastal schooners such as Benitz's traded up and down the coast, loading and unloading lumber, piling, and building stone quarried from the Salt Point area. Benitz and his neighbors sold potatoes, grain, deer hides, eggs, butter, apples, live ducks, and pigeons—all desirable commodities in Sonoma and San Francisco. According to the tax collector, Benitz was rated the fourth richest man in Sonoma County in 1858. This view shows Fort Ross Cove, c. 1875.

41

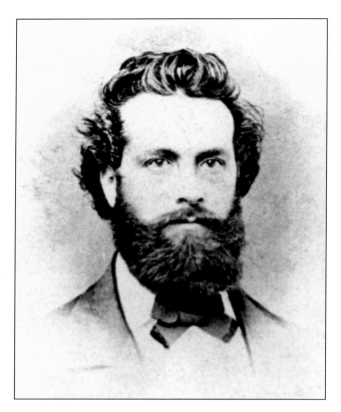

James Dixon wrote to his sister Catherine, March 7, 1868, " . . . while I was waiting for matters to mend in Ireland, being idle, I thought I would go on a prospecting tour, the Consequences was I struck Fort Ross. It being for sale and as I found it would suit me I purchased it. It contains 7000 acres of land, and on it is a large amount of Timber more than I can Cut off in Ten years." Dixon documented that he intended to farm the land, but there is little evidence that agriculture took place. Upon purchasing Ross, he immediately moved his mill and built a loading chute at Fort Ross Cove to ship lumber.

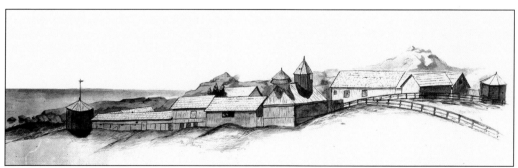

The Dixon/Fairfax period marked a philosophical change in land use of the area. Dixon was a bachelor intent on gaining quick profits from timber. Fairfax rarely visited, and his wife Ada only lived at Fort Ross in an effort to save money after she was widowed. For these men, the land was an investment, not a place to put down roots. After logging most of the timber on the property, Dixon sold some of his holdings in 1873 and moved his sawmill operation up the coast. Fort Ross is pictured here c. 1875 during the Dixon/Fairfax years. Most of the Russian buildings are still standing, as they were repaired or modified during the Benitz era.

Charles Fairfax came to California searching for gold in 1849, but turned to politics instead. When he married Ada Benham, they were given land in Marin County, in current day Fairfax. He purchased the Fort Ross property as an investment, and rarely visited. In 1868 Fairfax led the California delegation to the Democratic National Convention in New York City. He stayed on to visit family, became ill, and died of tuberculosis at the age of 40. Except for the Marin and Sonoma county parcels, he left his wife with little money.

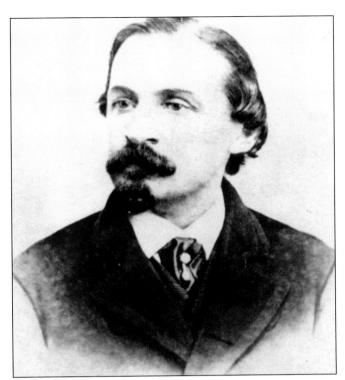

Ada Benham Fairfax was born to a distinguished family. After the death of her husband Charles, she was forced to consolidate her holdings. She moved to Fort Ross, occupying the former Benitz family home. She brought her social life with her. Several years later Ada moved to Washington, D.C. where she became an official hostess.

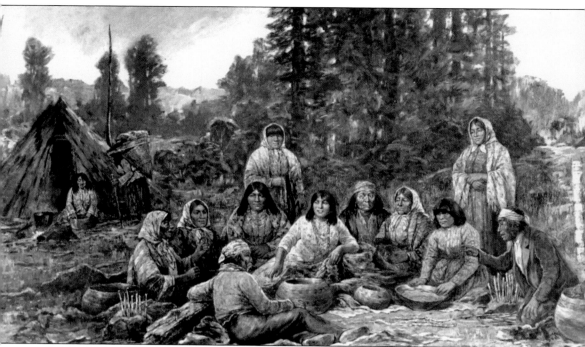

In 1848, the Native Kashaya still living outside the fort numbered 162. The Kashaya were employed by Benitz and his partner, taking on the farming and ranching chores required by such a large agricultural enterprise. As decreed by the federal government, Kashaya workers received board, lodging, and $8 a month salary. Dixon did not need a labor force for agriculture and instructed the Kashaya to leave Fort Ross. This image, *Indian Camp Near Fort Ross*, was painted in the 1880s by Henry Raschen. By this time the Kashaya had left Fort Ross and were employed as wage workers on ranches throughout the region. (Courtesy of the Oakland Museum of California; lent by the Mann Family Trust.)

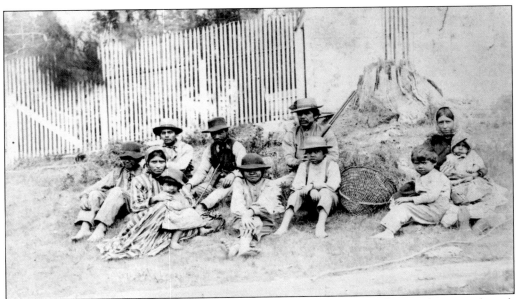

In the early 1870s, many Kashaya moved permanently to their traditional winter home in the oak grasslands northeast of Fort Ross. Charles Haupt, a rancher who had married a Kashaya woman named Molly, invited her people to live again at their old village, which was now on his ranch. This photo was taken in the vicinity of Salt Point. (Courtesy of the Salt Point Collection.)

In the 1870s work began on a road along the coast, linking the isolated settlements of Fort Ross, Salt Point, Fisks Mill, Stewarts Point, and others. Previously the road north was along the ridge two miles inland, with branches to each coastal settlement. Mail delivery to Fort Ross and points northward was no small feat; distances were long and roads were rough, with landslides, dense fog, and even the occasional holdup by bandit "Black Bart." This is Raymond and "Jack" carrying the mail in 1892.

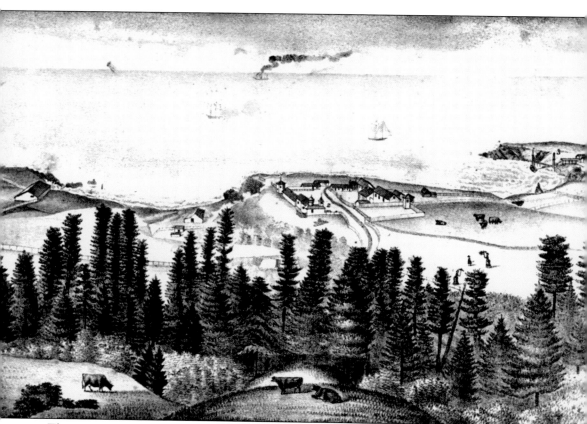

This view, "Old Fort Ross as Seen from the Hill," appears in *Thompson and West's Historical Atlas of Sonoma County, 1877.* Getting to Fort Ross was a considerable journey. "The start is made at eight o'clock in the morning from San Francisco and Fort Ross is reached at about six in the evening of the same day. First the road to Sausalito, then by train to the pleasant resort of Cazadero, at one o'clock—where the road ends. Here we were to take the stage . . . we reached Sea View, a little wayside tavern and post office, where the stage road climbs out on the ridge of the hills over Fort Ross and allows a glimpse of the ocean. There we transferred to a private team sent from the fort and driven by one of the good natured brothers that lease the hotel . . . the ride down to the Fort [is] three and a half miles . . . The great ocean lay before us, the redwood trees were about us . . . And at each turn of the winding road we could see Fort Ross, our goal, growing nearer and still nearer. We reached it at about seven o'clock . . ." (Charles S. Greene, *The Overland Monthly,* 1893.)

# Five

# Fort Ross as a Shipping Center
## The Call Ranch, 1873–1920

By his mid-thirties, George W. Call had accumulated substantial wealth and had traveled widely. He returned to California keen on finding land where he might ranch and raise his family. In 1873 Call purchased 2,500 acres of Dixon's northern parcel, including Fort Ross and its loading chute, for $35,000. He also paid $10,000 for livestock. Call settled at Fort Ross with his Chilean wife Mercedes Leiva Call and three young children; over the years nine children would be raised at the fort. Call continued to purchase land until he owned approximately 8,000 acres. He built barns, wagon sheds, and a smithy. Within a decade Call transformed Fort Ross into one of the most active small shipping, communications, and business centers along the northern California coast.

Fort Ross also became a tourist destination. Some would come to explore the old Russian colony, while others were drawn to the dramatic shoreline and inland forests. Until the 1920s when automobiles became popular, the sea was the primary route to Fort Ross. Call expanded on the transport of goods by sea begun by all the previous owners. He constructed a wharf and warehouse near the Dixon lumber chute, to export not only Fort Ross produce and timber but also that of neighboring farms and ranches. In 1897, Call put his own gasoline schooner, *La Chilena*, into weekly service to San Francisco. The weekly Schooner Day was a festive and busy occasion in the neighborhood, and the Call family was renowned for its hospitality. When the *Pomona* wrecked just offshore, Mercedes Call fed and cared for many of the passengers in the aftermath. "It's a fine thing to be wrecked so close to a milk ranch." said one passenger. (*Call Bulletin*, a San Francisco daily newspaper, 1936.) The Call era brought stability to a large stretch of the coast that would last for one hundred years.

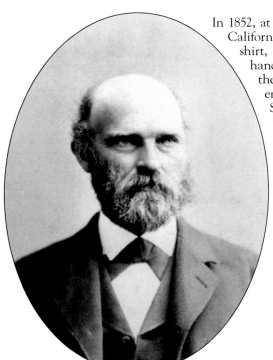

In 1852, at the age of 23, George W. Call left Ohio for California, carrying "his gun, pistol, one spare woolen shirt, one pair of blankets," and $1. He tried his hand in the gold mines, worked as a logger in the Humboldt area, and eventually acquired enough money to test his business acumen in San Francisco. He staged bear and bull fights while en route to Latin America, became a subcontractor for building railroads in Peru and Chile, and then opened Chile's first jute factory. While in Chile, Call met Mercedes Leiva, an attractive 15-year-old orphan being reared by relatives on a wheat *estancia*. They were married in 1866, and had several daughters. When their first son was born in 1872, Call decided to return to California to raise his family.

Mercedes Leiva Call as described by her daughter Laura Call Carr: "My mother was sixteen when she married my father, the 'gringo' who was twenty years older. She had dark hair and sparkling eyes . . . She was an orphan and had had no advantages, and almost no schooling. But Mama had a good business mind, a quick wit, and lots of good common sense. She was a natural cook and had a love of the beautiful, which showed itself in her handiwork and garden. She was a wonderful mother."

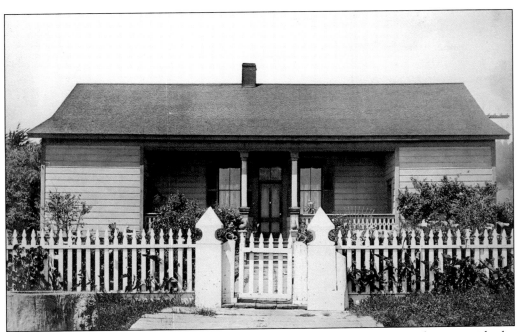

When his family outgrew the Rotchev house, Call began work on a new residence outside the fort compound facing the northwest cove. It was the Call family home for a century. After G. W. Call died in 1907, his sons Carlos and George H. managed the ranch. Mercedes Leiva lived in the house for another 20 years, and Carlos and his sister Emma lived there into their nineties. Now part of Fort Ross State Historic Park, the Call House has undergone restoration and is open for visitors. Below, the Call family is gathered on the front porch, c. 1900. From left to right, they are Mercedes, Ana Rosa, Ramona Pearce, Kathryn Kaiser, unknown, Emma, George W., and Mrs. Call. On the steps are Laura, Carlos, Mary, and Lucy.

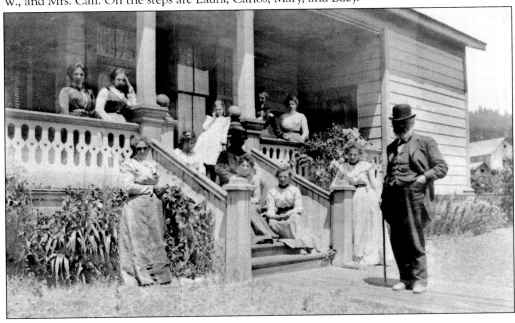

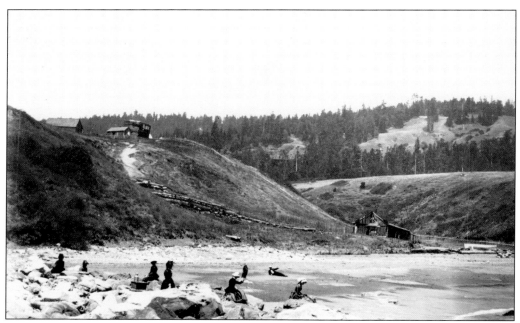

This photo taken by Ana Rosa Call shows a picnic at Fort Ross Sandy Cove, *c.* 1880. Remains of the Russian boat barn are still visible in the cove. Laura Call Carr wrote, "On Sunday mornings we went to the wonderful Sandy Beach, where we learned about the small creatures that dwelled there and which we studied under lamplight in *Cassel's History* from my father's bookshelves."

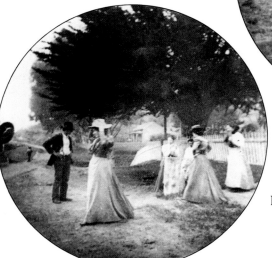

Emma and Laura Call take an afternoon stroll at Timber Cove in 1898 (above).
Seen at left are Laura, Ana Rosa, and Emma Call with friends, also in 1898.

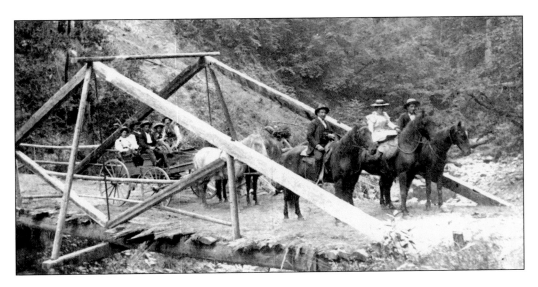

Carlos Call is driving (above) with friends and family in 1896. The photo below captures the view of the road past the Call house looking east in 1895. Laura Call Carr wrote, "There were no trees at the site; we planted most of them. I believe we planted all except the willows that grew in the little creek where my father built the new house . . . The northwest wind was prevalent and trees did not thrive on the level land that was exposed to it, so, on the slight rise that existed northwest of the house, my father had a windbreak of cypress planted. I remember the young trees being unloaded from the schooner, and several men planting them, and I remember again how we children watered all five hundred trees every day for what seemed an eternity."

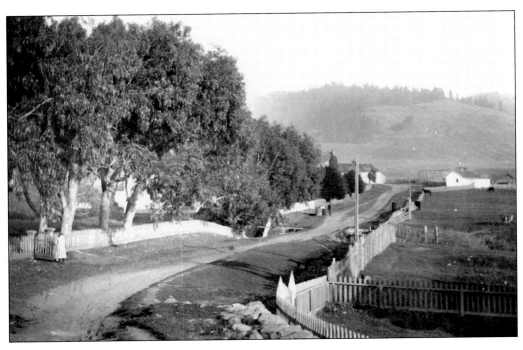

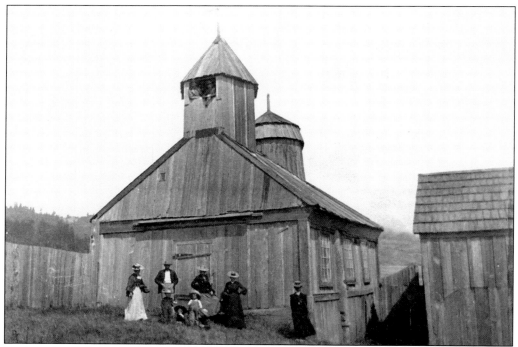

During the Call ranch era the Russian chapel was occasionally used for weddings, but it also proved a decent horse barn and apple storehouse. It is shown here *c. 1900.*

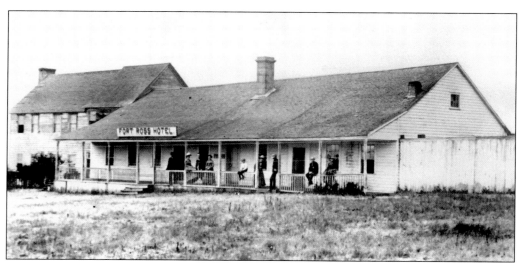

After the Calls built their family home outside the fort walls, Call leased out the Rotchev House as a hotel, as pictured here in 1880. The old Russian buildings housed a dance hall and a saloon as well; eventually there was a store, a post office, and a telegraph station. Fort Ross became a social center for residents of the area.

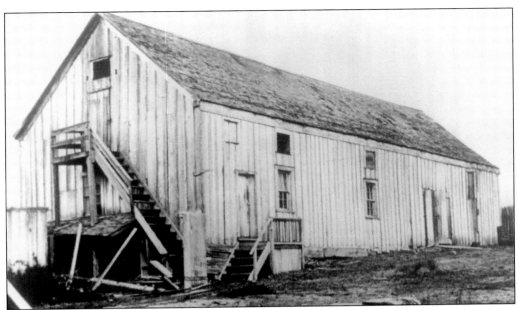

The Russian warehouse, pictured here in 1890, was used as a dance hall by the neighborhood. As Mercedes Stafford recalls, barn dances at Fort Ross were big social events: "When I was a child the dance hall was a very important building because it was where all the people came together from the whole countryside . . . The dances at the fort began to die out just as the picnics did with the use of the automobile."

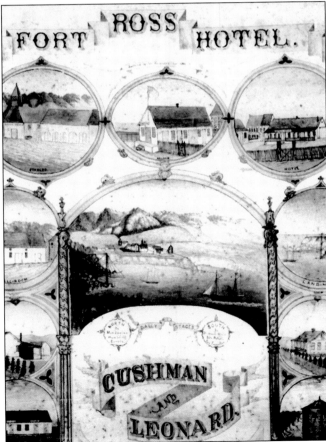

This 1878 broadside found in San Francisco promotes the Fort Ross Hotel as a tourist destination. The hotel provided lodging for the increasing number of visitors arriving from San Francisco and other parts of California, among them writer Gertrude Atherton and horticulturalist Luther Burbank.

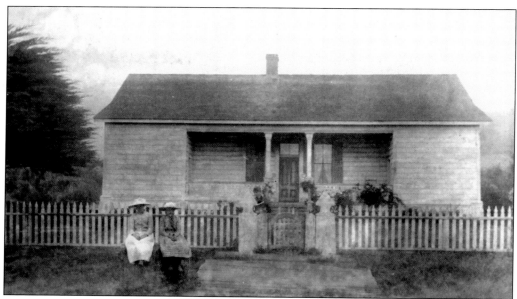

Two young girls are pictured in front of the Call home (above). It takes creativity to offer formal education in a site as remote as Fort Ross. In order to reach the 15-student minimum required of a school, Call made a point of hiring help who had families, and inviting neighborhood kids to attend the school. He also went so far as to require his oldest daughter to repeat eighth grade. When it came time for high school, Call bought a house in San Francisco so that his children could spend the school year in the city. The schoolhouse, shown below in 1900, was built on a bluff overlooking the cove in 1884. Over the years the school was moved several times to follow the student population. Although no longer in use, it can be visited today at Stillwater County Park.

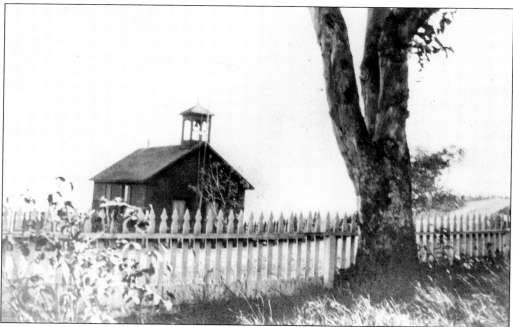

The Call children are riding in the family wagon. (Courtesy of Stafford Collection)

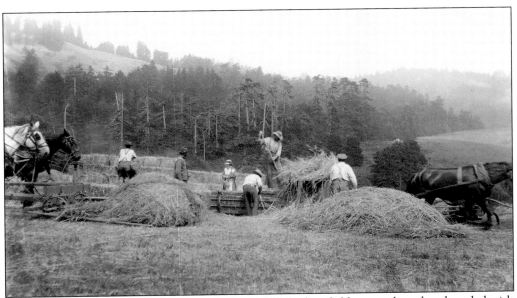

Here, workers bale hay at the Call ranch. Every fall the hay fields were plowed and seeded with grain to feed the horses and cows. Hundreds of dairy animals grazed on the hills. The butter made at the Fort Ross dairy was in great demand in San Francisco, with Call shipping more than 20,000 pounds of butter per year between 1875 and 1899.

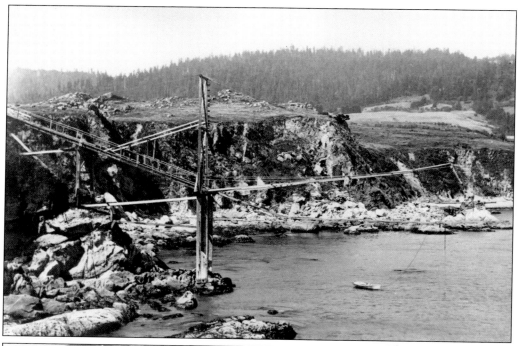

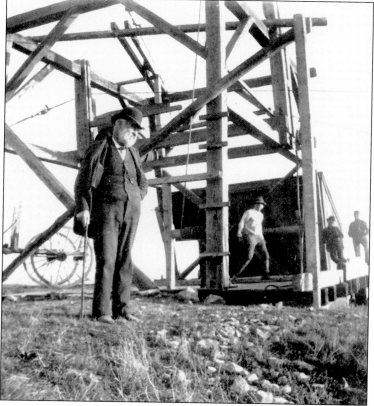

The Fort Ross port and landing chute in the northwest cove, pictured here before 1900, was used extensively by ranchers from the surrounding community. Neighboring farms and ranches hauled wood products as well as butter, hogs, apples, and hides to Fort Ross by four- and six-horse wagon teams over the narrow, winding, and precipitous dirt roads.

G.W. Call stands in front of the loading chute at Fort Ross, c. 1900. The chute was used for transferring products from the ranch to ships.

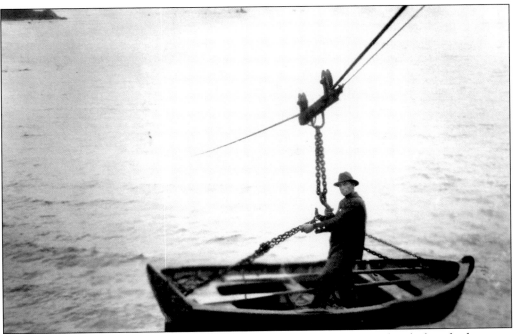

In addition to the chute, a high-wire rig could drop cargo down to the decks of schooners. Carlos Call's yawl was kept ashore and dropped from the high wire when needed. (Courtesy of San Francisco Maritime National Historical Park.)

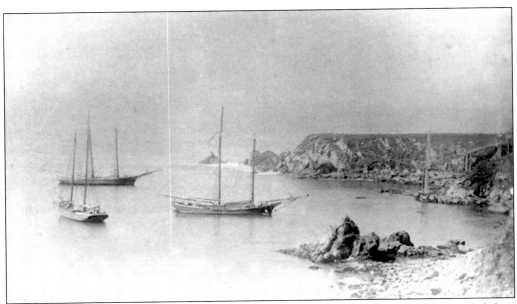

This view shows Fort Ross Cove, c. 1899. Carlos Call describes the three lumber vessels left to right: *Portia*, wrecked at Stewarts Point; *Christina Steffens*, wrecked at Timber Cove; and *Albion*, sold as a kelp harvester.

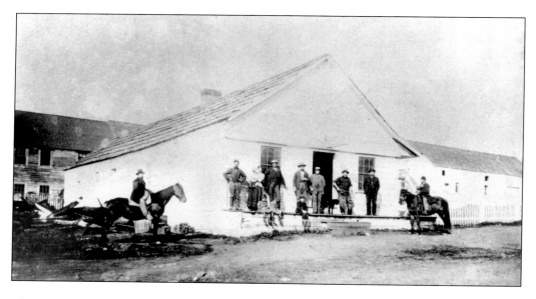

The Russian officials' quarters, pictured here in 1884, became the Fort Ross Saloon and Laundry. Lumber, railroad ties, and tanbark were stored on the bluff near the top of the chute. The photograph below was taken in front of the saloon. It shows the last load of tanbark to ship out of Fort Ross Cove, 1898. Sonoma County, with its once-thriving population of tan oak trees, was home to the earliest American-period tanneries; the Russians established a tannery at Fort Ross, and Stephen Smith built a tannery at Bodega in 1851. Later, companies such as Funcke and Company bought ranch land from which to export the raw material for their large-scale tanning operations.

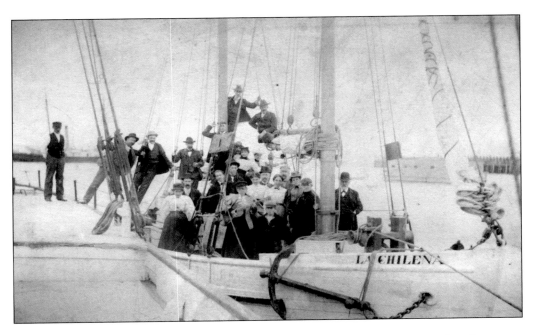

In 1897, Call put his own gasoline schooner, *La Chilena*, into weekly service to San Francisco; the eight- to ten-hour voyage south to San Francisco consisted of passengers (fare was $1), live animals, goods, and raw materials of all sorts. Flour, sugar, salt, crackers, tools, and medicines were brought north from San Francisco. The sea provided the principal route to Fort Ross until 1925. Travel by wagon was possible, but distances were long, roads were rough, and the trip was more costly. To travel from Fort Ross to Duncans Mills via stage cost $5, and passengers would then transfer to the train and ferry to reach San Francisco. Above, *La Chilena* is outbound from the harbor at Fort Ross in 1901. *La Chilena* was replaced in 1899 by the larger *Mary C*, shown below. (*La Chilena* courtesy of Stafford Collection.)

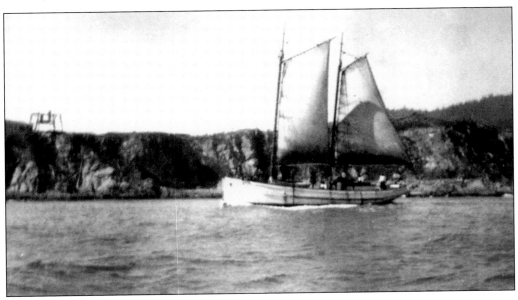

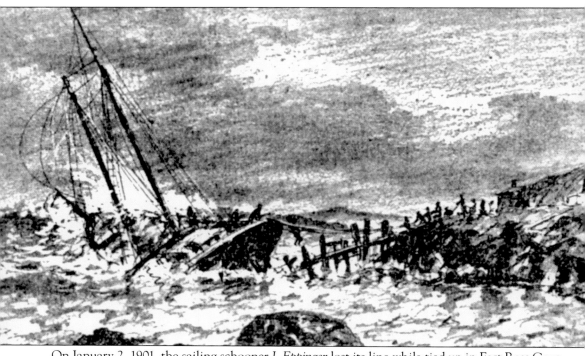

On January 2, 1901, the sailing schooner *J. Eppinger* lost its line while tied up in Fort Ross Cove during a storm, and quickly struck rocks. Strong winds kept the crew from throwing a line to rescuers onshore. Tied to a rope from the shoreward side, Carlos Call swam out to grab the ship's line, and was then pulled back to shore. All six seamen were able to escape the ship on the lifeline. The ship broke up shortly thereafter.

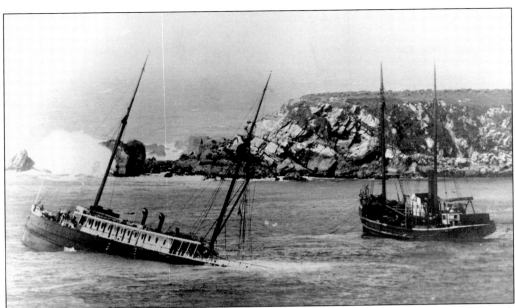

The *Pomona*, a coastal steamer that regularly traveled from San Francisco to Eureka, struck a submerged rock about two miles south of Fort Ross Cove and was wrecked at Fort Ross in 1908. Much speculation took place about why the schooner was traveling so close to shore. " 'We stood in because so many of the women were seasick' the captain is quoted as saying, but some of his passengers asserted yesterday that the real reason was not seasick women, but orders from the company to save coal and ease up on defective boilers." (From the *Call Bulletin*, a San Francisco daily newspaper, 1936.) (Below courtesy of the Stafford Collection.)

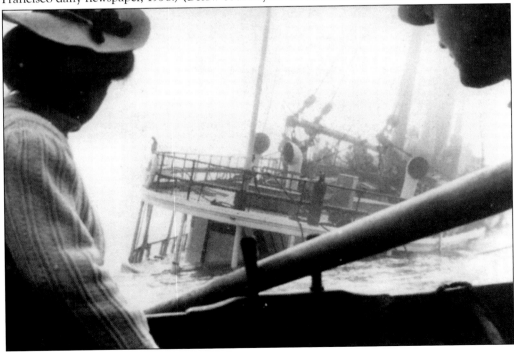

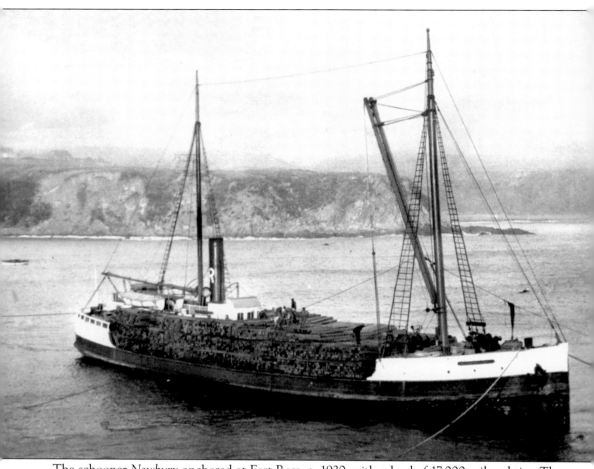

The schooner *Newbury* anchored at Fort Ross, c. 1920, with a load of 17,000 railroad ties. The shipping era died out at Fort Ross in the 1920s.

G.W. Call hired 14 Chinese laborers and an Irish foreman to build a new road south along the cliffs from Fort Ross to Meyers Grade, and to widen the road north of the fort to Kolmer Gulch. The project cost Call approximately $7,000. Call's earlier work overseeing the building of railroads in the Andes mountains of Peru probably gave him the insight that such roads could indeed be built, and work began in the late 1870s. The road was closed by landslides a decade later, and did not reopen until the early 1920s, when the mode of transportation began to change, even in this remote area. The automobile above is clearly unaccustomed to the lay of the land; below an automobile is parked in front of the Russian officials' quarters in 1911.

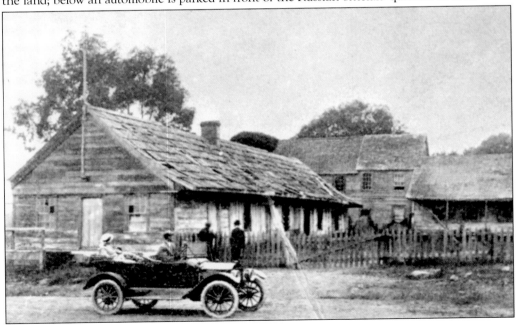

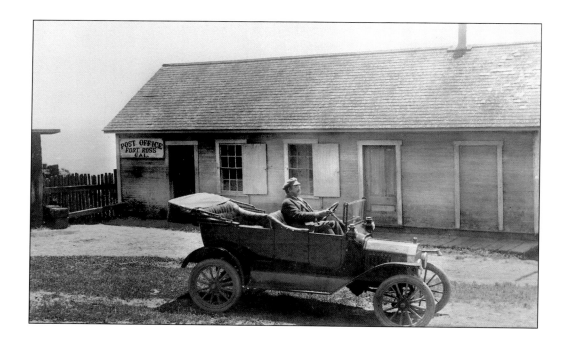

The Fort Ross Post Office, located just outside the stockade, is pictured above in December of 1914. The south end of the building was the post office, and Postmaster "Uncle Billy" Morgan's living quarters were on the north end. When Morgan, a beloved longtime Fort Ross resident and the first owner of a Model T in the area, died in July of 1915, the door on the north end was never opened again; the public used the south door exclusively. The post office ceased operations in 1928.

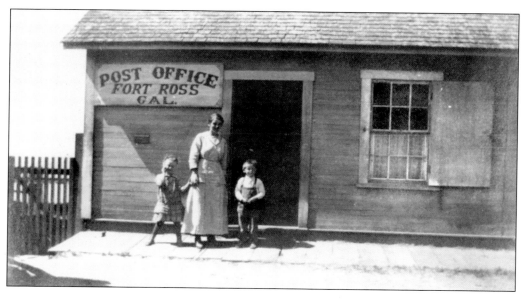

Mercedes Call cultivated an extensive flower garden bursting with unusual species, including passionflower, heliotrope, a rare black lily, and forty varieties of fuchsia. She was a friend of famed horiculturist Luther Burbank, and an early member of the American Fuchsia Society. Ship captains who anchored at Fort Ross often brought exotic plants back from their travels to give to Mercedes, some of which she hybridized with local plants.

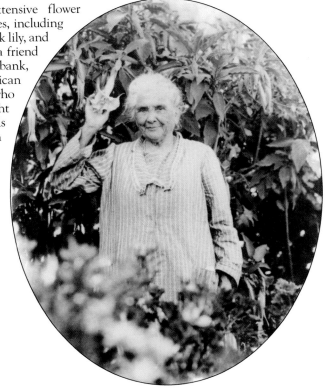

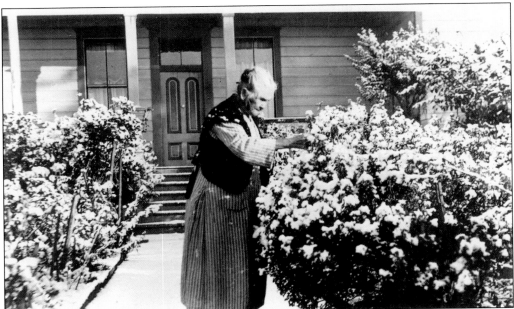

Mercedes Call continued to live at Fort Ross after her husband's death in 1907. When asked if she was lonely during her 26 years of widowhood, Mercedes answered, "Never, so long as I can be with my flowers!"

Until the 1870s there was no road connecting the coastal towns directly; they were accessible only via the ridge road. G.W. Call organized the construction of a road that traveled along the coast, but a decade later landslides closed it. Throughout its history the coast road has been a challenge to maintain: "Lew Miller, a skillful stagecoach driver, took the Board of Supervisors on a trip to Duncansville, across Wright's Ferry, and up the coast a ways to determine the need for a new road. They were convinced." The road was permanently reopened in 1925. (Courtesy of the Stafford Collection.)

A detail from the postal route map of North-Central California shows the 1884 mail service offered to the Sonoma North Coast.

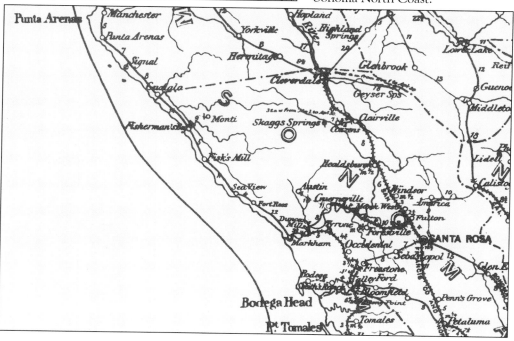

## *Six*

# THE SURROUNDING COMMUNITIES
## JENNER TO THE SEA RANCH

Fort Ross was the first European settlement along the Sonoma North Coast, but by the middle of the 19th century the old Russian colony had many neighbors. In the 1880s the Sonoma coast could be described as having a sawmill in every gulch and a chute at every marginally-hospitable coastal indentation.

Over time many of these sites developed into small towns, providing amenities such as general stores, hotels, possibly a stage stop. From the Gualala River to the mouth of the Russian River, the coast is populated by small unincorporated towns where locals once felled timber, stripped tanbark, quarried sandstone, or grazed cattle and sheep. Although logging and quarrying enterprises no longer dominate the landscape, some of the towns remain, often bearing the names of the men who first established commerce along this rugged coastline. By the early 1900s the lumber industry and coastal shipping were in decline, the land was overgrazed, and people moved away from the area. During Prohibition, locals turned to smuggling liquor via the sea. Black Point and Del Mar Landing in the old German Rancho, known as Rancho Del Mar—The Sea Ranch—became well-known spots for transporting bootleg.

In the 1920s the road along the coast between Jenner and Gualala was built, and coastal shipping was replaced by automobiles and trucks. Slowly, tourism became important, as the coast attracted urban visitors who came to fish, hunt, and enjoy the beaches in this wild and pristine environment.

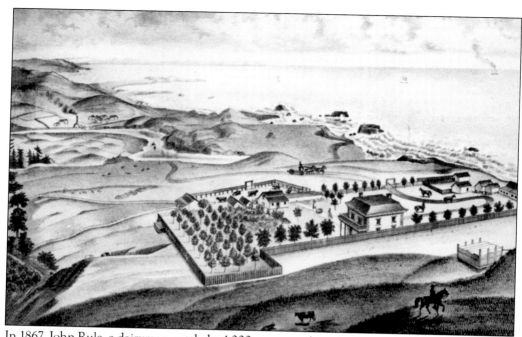

In 1867, John Rule, a dairyman, settled a 4,000-acre parcel on the Rancho Muniz about six miles west of Duncans Mills. The Rule Ranch, located above Jenner, is pictured here in *Thompson and West's Historical Atlas of Sonoma County, 1877.* John Rule's son Charles later sold some of this land located on the Russian River in the present town of Jenner to the A.B. Davis Lumber Company. Mill workers and their families moved to the site and Jenner became a town with its own post office in 1904. A year later the Jenner School was established for the children of the lumber mill workers. The mill settlement of Jenner, after 1900, is pictured below. (Courtesy of Elinor Twohy.)

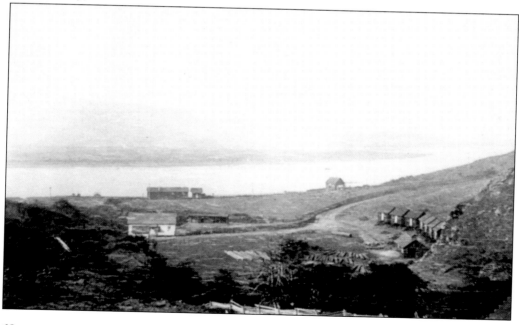

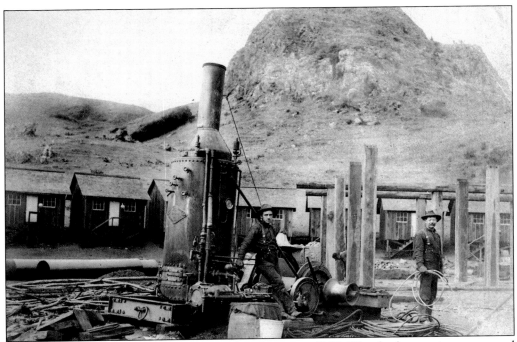

This donkey engine and crew are pictured at Jenner, c. 1900. The donkey engine, so named because it is half of a horsepower, provided portable power for lumbering operations in more remote areas. Mill workers lived in the row of houses located behind the engine. Some of Jenner's row houses still exist.

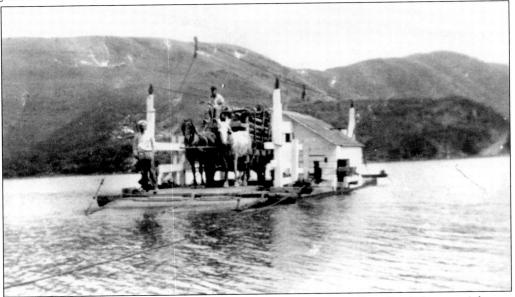

Travelers crossed the Russian River via the ferry crossing at the Willow Creek ferryman's house. Alex Cuthill ran this ferry every day (except when the river was flooded) from 1918 to 1931, when the bridge across the river was completed. Note the horses traveling on the ferry in this early 1900s photo. (Courtesy of Elinor Twohy.)

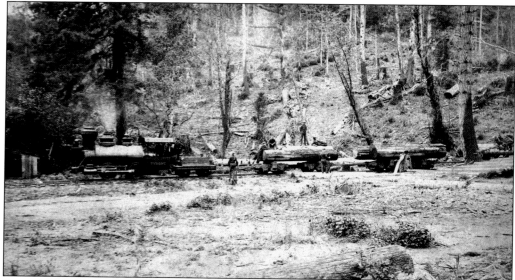

Samuel and Alexander Duncan originally set up a mill at Salt Point, but in 1860 they moved their logging operations to the Russian River near the present site of Bridgehaven, across the river from Jenner. From 1862 until 1877, a horse-drawn railway carried lumber from Duncans Mills out to the coast to a point south of Wrights Beach called Duncan's Landing, where two-masted schooners carried the lumber to San Francisco.

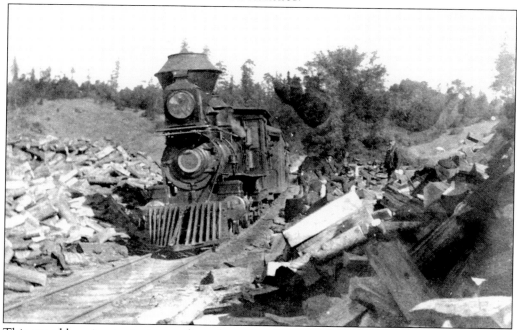

This wood-burning train is traveling through a Duncans Mills logging camp. Train tracks crisscrossed the area, as train transport became the preferred method to move timber to the urban centers and transport tourists from the cities for a quiet rural holiday. Train travel declined rapidly after the automobile was introduced; tourists drove to their destinations, and trucks were used to haul timber and other raw materials from the coast.

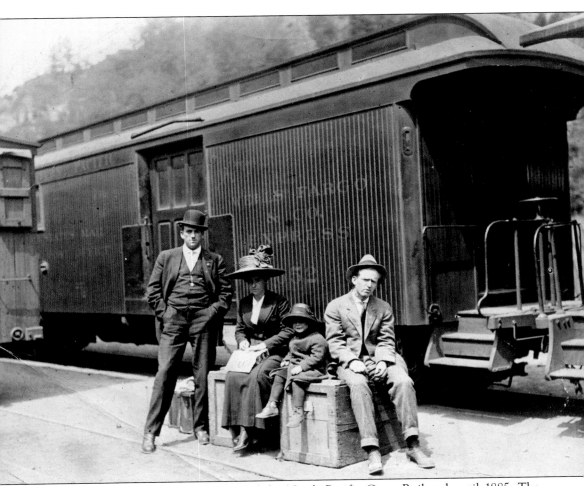

Duncans Mills remained the terminus of the North Pacific Coast Railroad until 1885. The Duncans Mills company owned and operated most of the town. The general store had a post office, rooms for lodgers, and a dance hall. Travelers to points north—Seaview, Fort Ross, Plantation, Salt Point, Fisk Mill, and Stewarts Point—could take the train a short way to Cazadero, where they would then travel by stage to their destination. Travelers pictured here, labeled only as "Billy Tuescher (child) and his mother in her favorite hat," are resting at the Duncans Mills station, c. 1911.

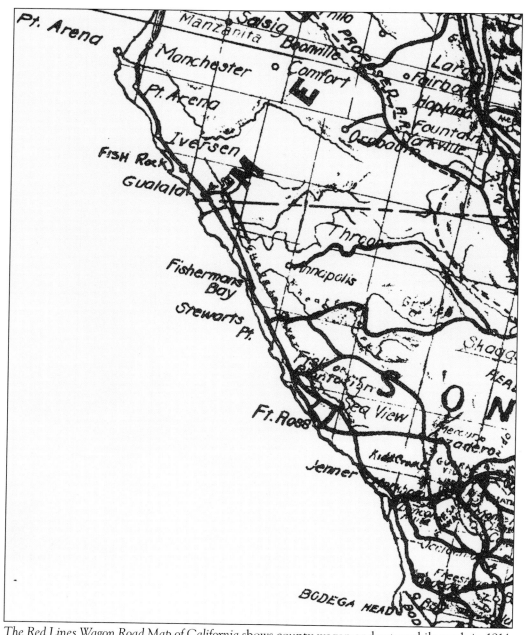

*The Red Lines Wagon Road Map of California* shows county wagon and automobile roads in 1914. (Courtesy of The Complete Map Works, San Francisco.)

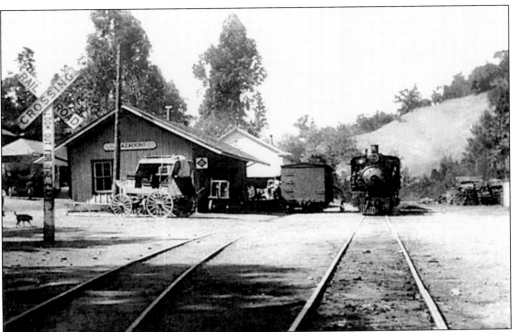

In 1916 Cazadero is the end of the train line, but the stage is waiting to take travelers and goods north.

Seaview, shown here after an unusual snowstorm, provided a much-needed stage stop along the sparsely-populated route from Cazadero to Gualala. Wells Fargo and Company maintained a horse barn at Seaview to provide a rest stop for its horses.

These travelers are taking the stage from Cazadero to Plantation.

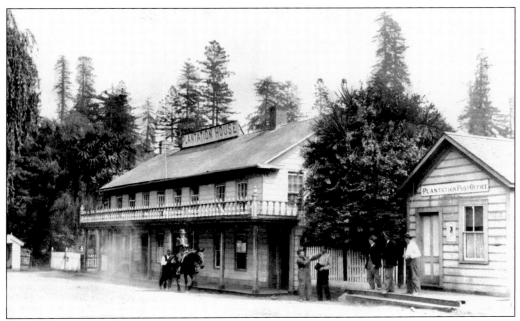

Plantation House and Post Office are shown above, c. 1890. Plantation House was a travelers' hotel built in 1871 by Joseph Lutringer, an Alsatian who had come west after the Civil War. Plantation was a summer destination for visitors from San Francisco and environs, offering a hotel, bar, and stage stop. The Plantation Bar, shown below c. 1890, is pictured, from left to right, with Walter McKenna, Jim McKenna (bartender), and Jim Boda.

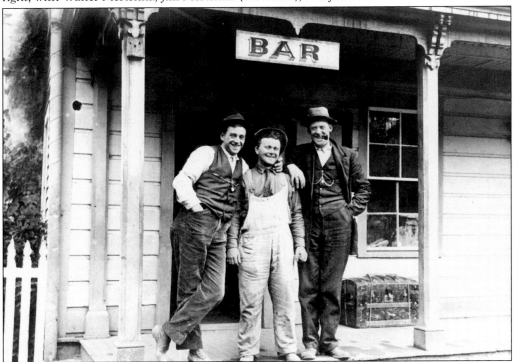

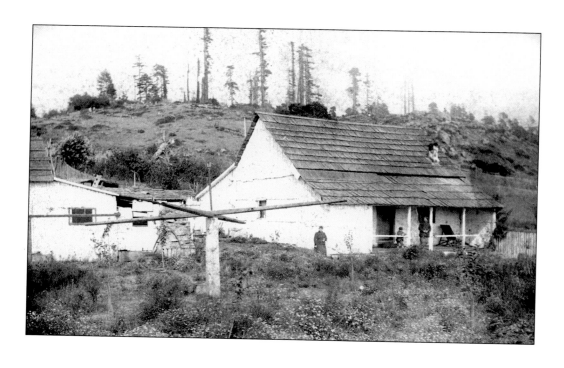

As early as 1863 Timber Cove, shown above, was a bustling lumber shipping point with about 300 inhabitants. The landing at Timber Cove is pictured below.

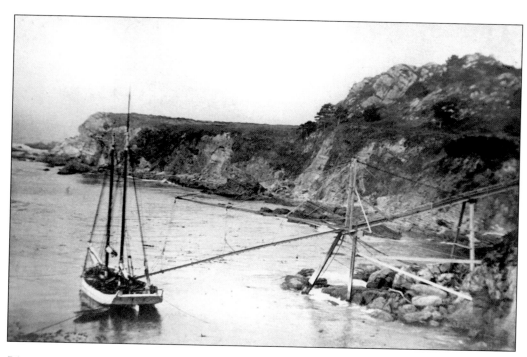

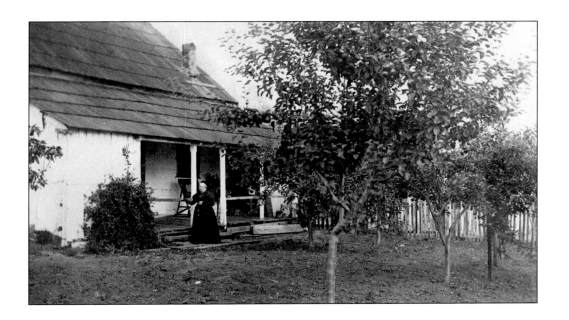

Josephine Benitz is pictured above at her Timber Cove house in 1898. Although she never lived there, she inherited the farm from her parents, Michael and Josephine Kolmer. They had been given the property by Josephine's husband, Wilhelm Benitz, when he owned Fort Ross and environs. Although the Benitz family moved to Argentina after the sale of Fort Ross, Josephine returned to California to visit on several occasions. The picnic at Muniz Ranch shown below was hosted by the Call family in 1898 in honor of her visit.

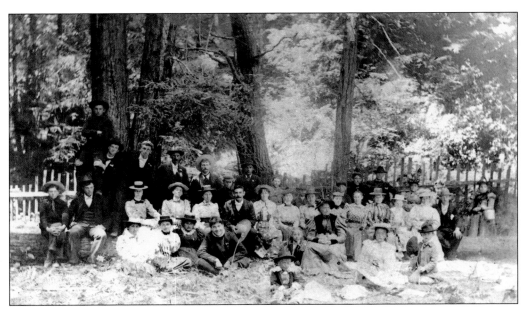

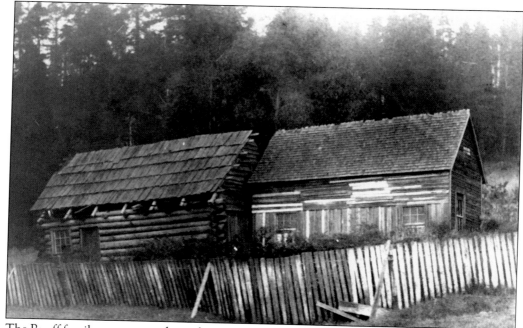

The Ruoff family was among the earliest European families in the area. Their cabin at Stillwater Cove was built in 1852.

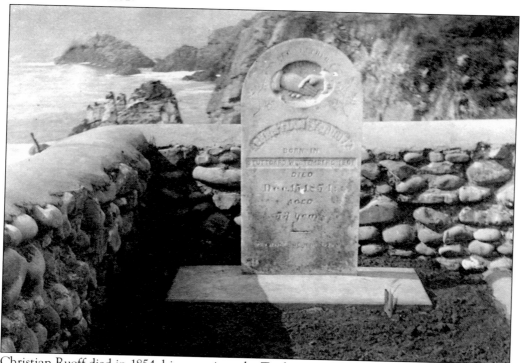

Christian Ruoff died in 1854; his grave is at the Timber Cove Cemetery. The Ruoff family was one of the first to establish a cemetery along the waterfront. There are numerous burial sites and cemeteries along the coast, many on private land.

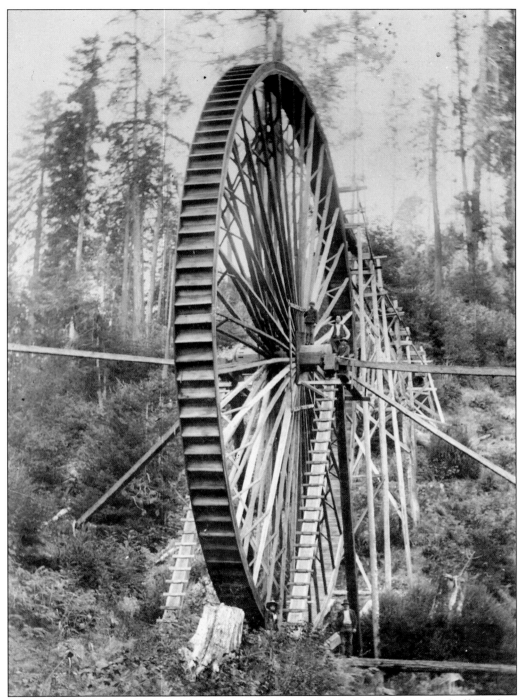

This great water wheel, 60 feet in diameter, was built entirely of split timbers in Stockoff Creek at Stillwater Cove by Happy Jack Howard and William Haily in 1895. Carlos Asa Call is standing on the hub. The wheel was built to power a logging operation, but lack of timber rights stopped the project.

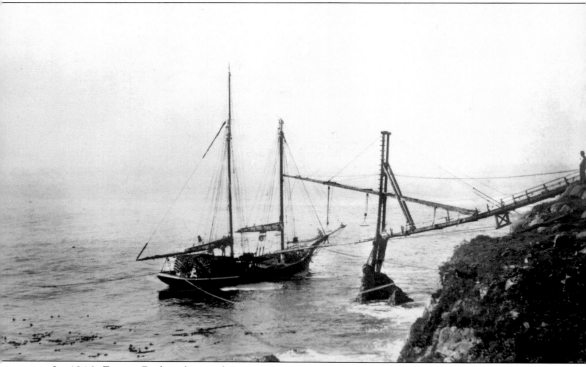

In 1846, Ernest Rufus obtained a Mexican grant to the land west of the coastal ridge, from southern Salt Point to the mouth of Gualala River. He named it Rancho de Herman, but it was commonly called the German Rancho. By the mid-1850s, lumber schooners left Salt Point every two or three weeks, carrying from 40,000 to 100,000 board feet of lumber to a San Francisco firm. "The manner of loading is down a chute built from the top of the bank down, twelve feet above high water, and from this is an apron projecting over the water twenty-five feet from end of chute, supported by shears resting on rocks at end of chute. Where the apron and chute connect there is a brake to check the headway of the lumber coming down, and at the end of the apron a man stands to check the speed it may acquire coming from the brake to the end of the apron. Three men are employed to bring the lumber to the head of the chute and place it so that it will slide down – and two men on the chute and apron to ease it down." (*Sonoma Democrat* newspaper, September 11, 1875.) (Courtesy of the Salt Point Collection.)

The Salt Point Hotel was built in 1870 but collapsed in 1923. Salt Point was so named because Kashaya collected salt from cliffs and crevices of the rocky shoreline. During the mid-1800s, sandstone from Salt Point was used to construct San Francisco's streets and buildings, as well as the naval facility at Mare Island. Quarried rocks with visible drill holes can still be seen along the marine terrace north of Gerstle Cove.

In 1874, the Salt Point ranch was owned by Funcke & Company of San Francisco. The Salt Point Hotel had 15 rooms and a large hall. There was a general merchandise store, a carpenter's shop, a blacksmith shop, and a chute for loading vessels. The ranch shipped about 5,000 cords of wood annually, and used the surrounding land for cattle grazing. The citizens of Salt Point Township organized parties and holiday celebrations that brought in guests from the ridge and coast.

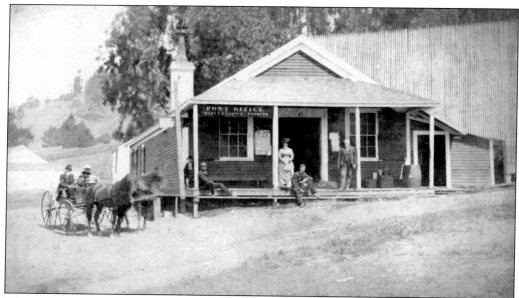

John Colt Fisk came to the Sonoma coast looking for a place to operate his steam sawmill to cut timber for the railroads. The mill and shipping point developed into a small village of several houses and possibly a store. "I have seen with admiration the immense labor performed in opening up a timbered ravine and getting out the lumber—the roads have to be graded, the shutes to be constructed, the railroads to be built, the villages to be founded for the workmen, the shops, barns, stables, etc. When the best of the timber is cut out, all has to be abandoned . . ." (*Sonoma Democrat* newspaper, September 6, 1873.) This post office and Wells Fargo stage stop at Salt Point, above, is located near the sites of Fisk Mill and Kruse Ranch. The structure is dilapidated but still stands beside Highway One in Salt Point State Park. (Courtesy of the Salt Point Collection.)

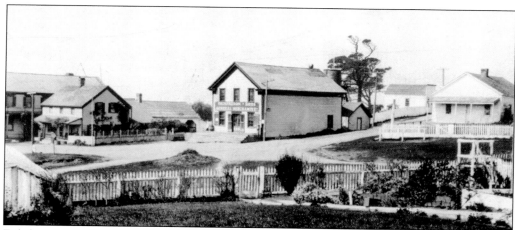

Fisk later moved north to Stewarts Point, a town previously developed by the Stewart family which offered a summer getaway for Bay Area residents. Fisk joined his brother Andrew in managing a store, hotel, saloon, and blacksmith shop. Herbert A. Richardson came to Stewarts Point in 1878, and became the proprietor of the Stewarts Point operation. Richardson family members are the owners to this day. (Courtesy of the Richardson family.)

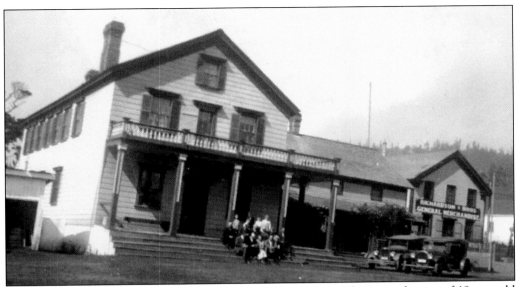

Stewarts Point, pictured here in 1926, was quite a lively place. The journal entry of 19-year-old Luvia Horrisberger during her 1905 vacation at the Plantation resort describes an evening at Stewarts Point Hotel: "So.[phia] and I were quite popular, being city girls, there was only about one other city girl there, besides us. The Quadrille was the leading dance and even though we didn't know how to dance it, we soon caught on, because the floor manager would call out all the different figures . . . I've been to a good many dances but have never enjoyed one as I did this! We only sat about two dances the whole night." (Courtesy of the Richardson family.)

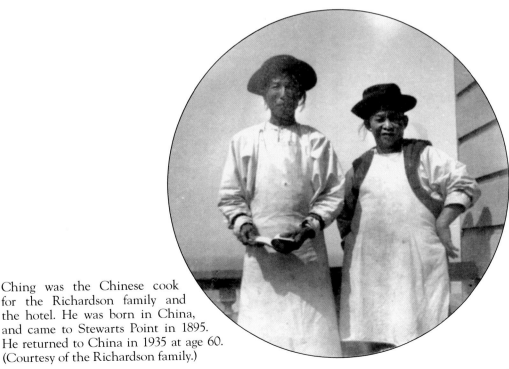

Ching was the Chinese cook for the Richardson family and the hotel. He was born in China, and came to Stewarts Point in 1895. He returned to China in 1935 at age 60. (Courtesy of the Richardson family.)

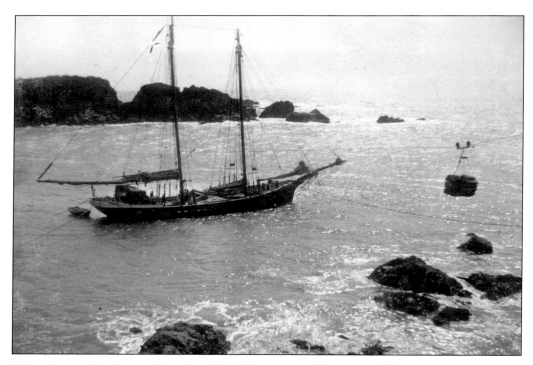

This schooner loading cordwood and the ladies posing below are at Fisherman's Bay, Stewarts Point. (Courtesy of the Richardson family.)

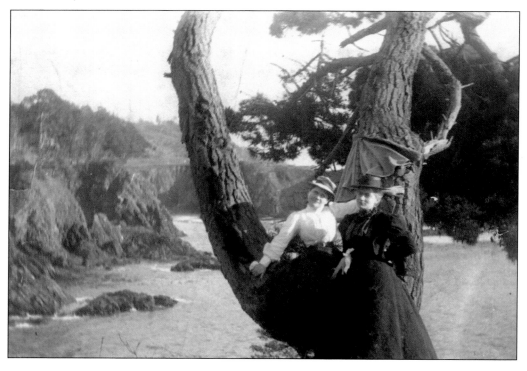

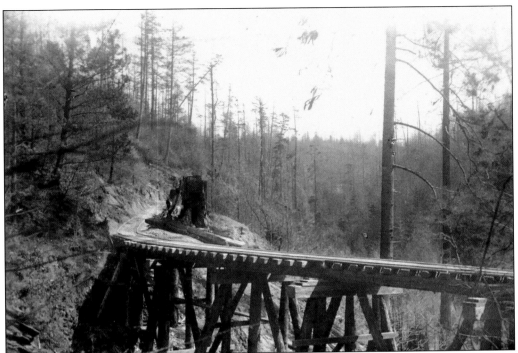

In the 1890s, this trestle was part of the route inland from Stewarts Point, east along a steep and rugged dead-end route to the south fork of the Gualala River and Hauser Bridge areas. Timber was hauled out to the coast, and supplies brought in to the residents of the area. (Courtesy of the Richardson family.)

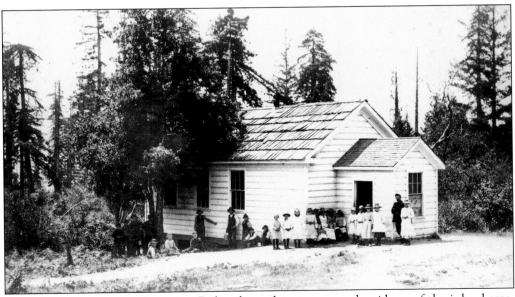

The school house, located on King Ridge above the coast, served residents of the inland area. (Courtesy of the Salt Point collection.)

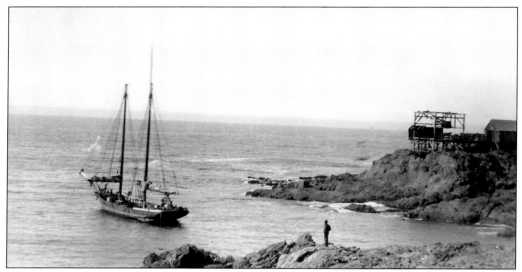

Ernst Rufus's "German Ranch" extended from Salt Point to Gualala. He sold portions of the ranch to various Europeans, Americans, and other Germans, one of whom was William Bihler. Bihler ran a profitable cattle business and built the booming lumber town of Bihler's Landing at Black Point near the present site of The Sea Ranch Lodge. Pictured is a schooner unloading at the Black Point Warehouse, a structure used for storage and dancing, c. 1870. (Courtesy of The Sea Ranch.)

In 1920, H.A. and Fontaine Richardson contracted with the state to build Highway One from Jenner to Gualala. It was a narrow, winding road following the contour of the land, but sufficiently navigable that automobiles and trucks replaced shipping transport on the Sonoma North Coast. This image shows the bridge over McClelland Gulch at Stewarts Point. (Courtesy of the Richardson family.)

Pictured here, from left to right, are Kashaya girls at Stewarts Point: Nettie Manuel, Alice Meyers, and Annie Jarvis Sheard. (Courtesy of the Richardson family.)

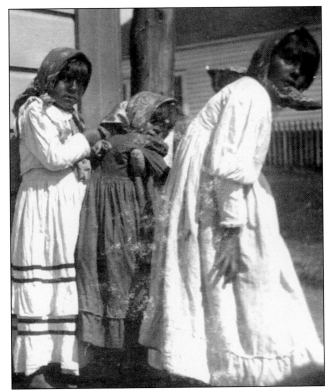

A Kashaya family poses at Stewarts Point. (Courtesy of the Richardson family.)

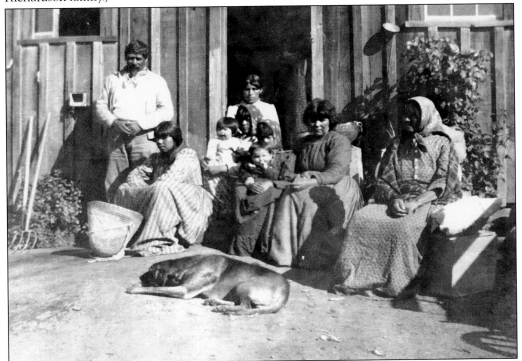

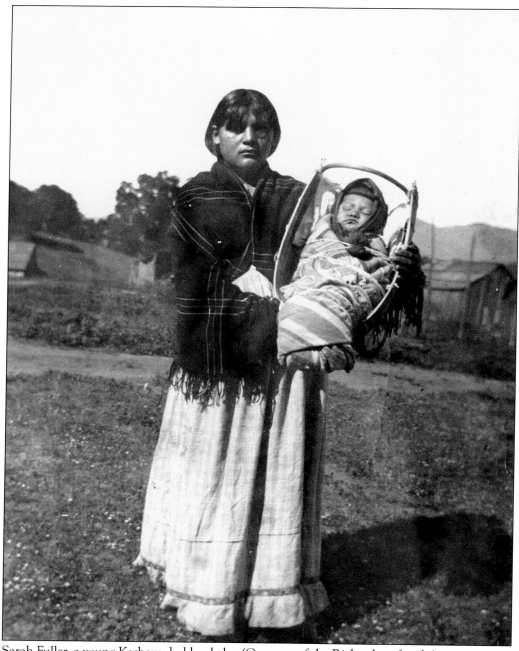

Sarah Fuller, a young Kashaya, holds a baby. (Courtesy of the Richardson family.)

# Seven

# ASSEMBLING A PARK
## 1906 EARTHQUAKE
## AND RECONSTRUCTION

In July of 1903 George W. Call sold a portion of his property to the California Historical Landmarks League. This sale included the fort compound, which was turned over to the State of California in March 1906. Fort Ross became one of California's first historic state parks and began its slow and repetitive process of restoration.

Time and weather had damaged the Russian structures long before Fort Ross was designated a historic park. Even before the Russians left in 1834, the governor of Russian America, Baron von Wrangell, commented on the neglected state of the structures: [they] "are neatly and orderly maintained and look comfortable, even handsome. However, almost all the buildings, as well as the stockade wall and watch-towers, are so old and dilapidated that either they need repairing or else they should be replaced by new structures." Although there was some rebuilding during the last decade of Russian occupation, during the following American ranch period many of the buildings, even the chapel, were further deteriorated by use as agricultural outbuildings, housing farm animals and crops. The ranchers modified the buildings, and although these changes often made the structures stronger, they obscured many Russian construction details. When the state acquired the fort in 1906, the Russian blockhouses and some of the stockade were still standing, as were the chapel, officials' quarters (saloon), Rotchev House (Fort Ross Hotel), and the two adjoining Russian warehouses. More damage ensued during the 1906 earthquake, which took place less than a month after Fort Ross became a state park. Restoration began a decade later with the 1916 chapel reconstruction, carrying out what has now been almost a century of rebuilding Fort Ross. Today the Rotchev House is the only remaining original Russian-built structure; the five other buildings in the fort compound are reconstructions.

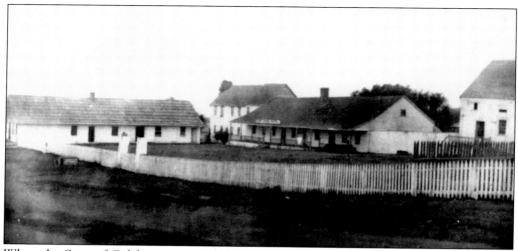

When the State of California acquired Fort Ross, its Russian-built structures, much modified during the American ranching years, lined the "highway" which at that time divided the former Russian fort. The officials' quarters, Rotchev House as the Fort Ross Hotel, and Russian warehouse appear, from left to right. This picture was taken *c.* 1890 from the Russian Chapel, which is just across the road from the hotel.

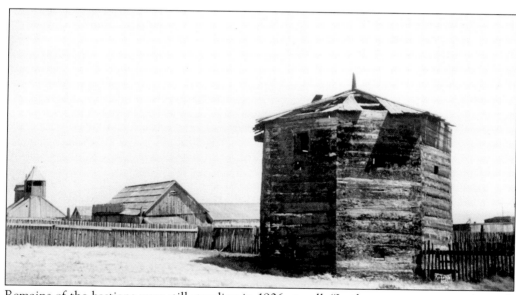

Remains of the bastions were still standing in 1906 as well. "In the two corners opposite each other, one overlooking the mountains and the other overlooking the sea, are mounted 12 pieces of artillery up in two towers or lookout platforms. Each piece is of eight caliber and six are located in each tower" (Mariano G. Vallejo, 1833). Fort Ross was never attacked, but this view shows the northwest blockhouse, which once guarded the fort, in 1890.

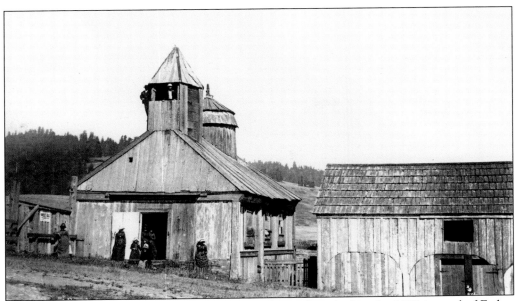

The chapel, built by the resident Russians *c.* 1825, was described in the 1836 journal of Father Ioann Veniaminov: "The chapel is constructed from wooden boards . . . It has a small belfry and is rather plain; its entire interior decoration consists of two icons in silver rizas." This 1888 photograph is among the earliest of the chapel. By 1906 it is likely that attempts to preserve the chapel had already modified its original appearance.

The remains of the Russian cemetery, pictured here in 1895, are situated across the ravine on a bluff east of the fort. "To the northeast at a cannon shot's distance they have their cemetery . . . In it there is a . . . mausoleum atop a sepulcher of three square steps, from larger to smaller. Above these was a pyramid two yards high, and over it a ball topped off by a cross, all painted white and black, which is what most attracts one's attention when you descend from the mountain. Over another burial . . . they placed only something like a box, and over the Kodiaks a cross . . . " (Father Payeras, 1822). The cemetery monuments seen in early photographs, like that at right, no longer exist.

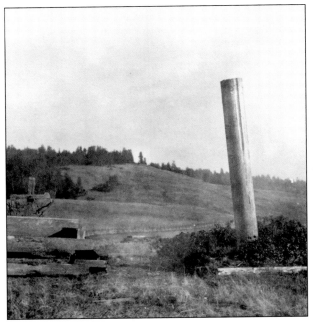

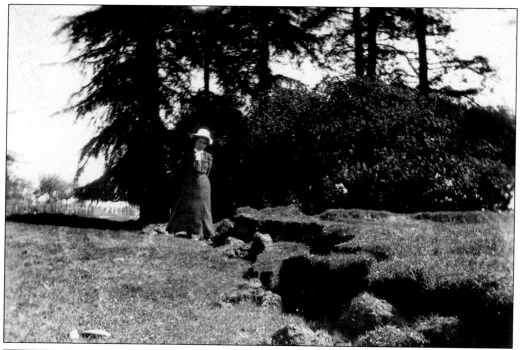

Miss Rosa Call is standing by the earthquake surface ruptures on the San Andreas Fault after the 1906 earthquake. The San Andreas fault line runs along the base of the Fort Ross hills. Fissures almost a meter across were observed after the 1906 quake.

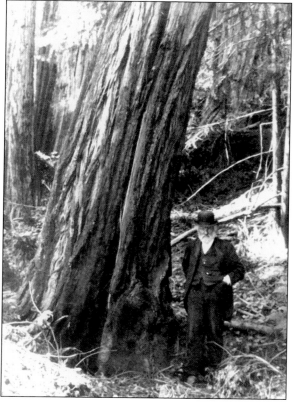

G.W. Call stands by the "earthquake tree," an old-growth redwood that was split in the 1906 earthquake. The tree became an obligatory stop for visitors to Fort Ross.

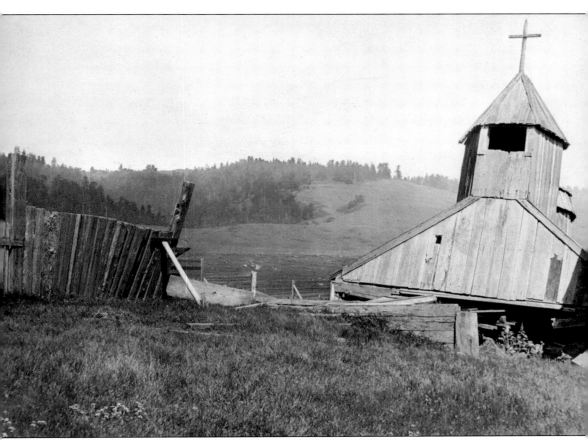

During the 1906 earthquake, the chapel walls caved in, and the floors and foundation were reduced to rubble. Fortunately, the roof fell to the ground intact. The propped-up fence at the left is the only remaining portion of the original Russian stockade.

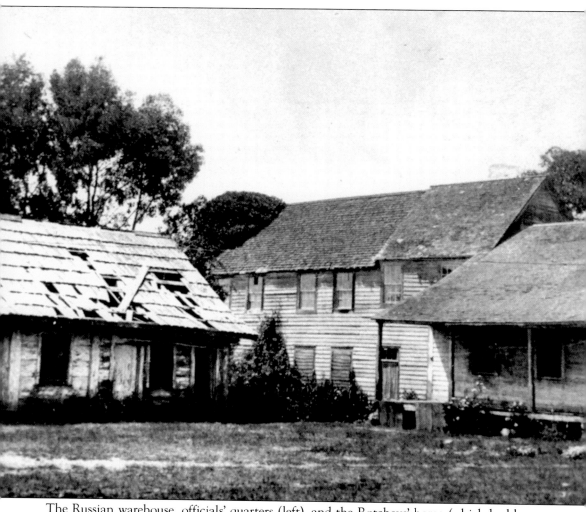

The Russian warehouse, officials' quarters (left), and the Rotchevs' home (which had become the two-story Fort Ross Hotel) had all been modified extensively throughout the ranch era, and remained standing after the earthquake. The officials' quarters and Rotchev House with the Benitz additions are pictured c. 1916.

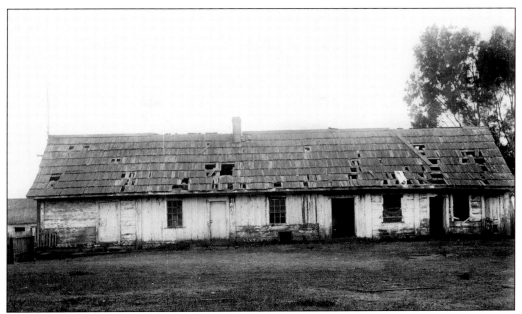

The officials' quarters pictured here in 1916 were constructed before 1817 and were originally the site of company workshops. They were refurbished in 1833 to provide accommodations for company officials and visitors. During the ranch era the building served as the saloon and laundry. This structure was one of the longest-surviving original Russian buildings; unfortunately it was dismantled when its timbers were used to reconstruct the chapel in 1916.

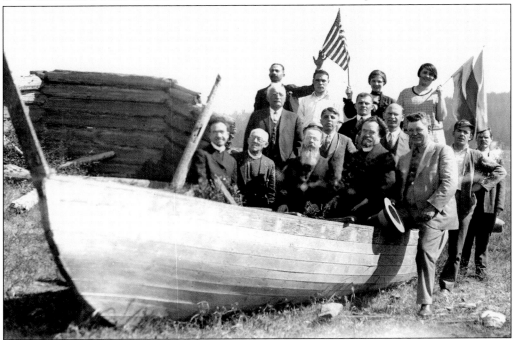

A Russian Orthodox group visited Fort Ross on July 4, 1910. The Orthodox Church in America continues to celebrate this holiday at Fort Ross in the 21st century.

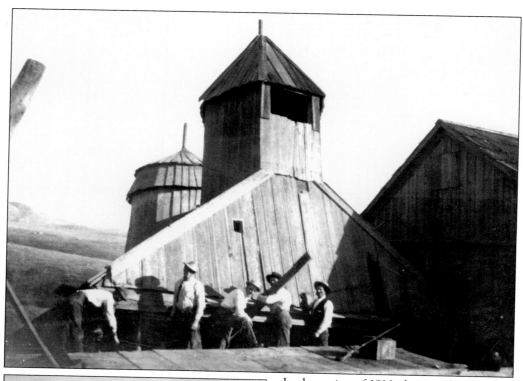

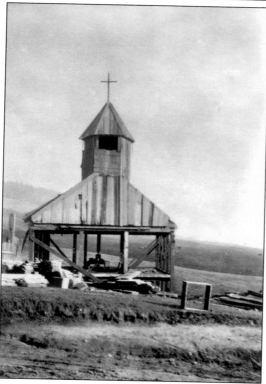

In the spring of 1916, the state legislature appropriated $3,000 toward reconstruction of the chapel. Work commenced under the direction of Mr. McDougall, state architect, who appointed George W. Call's son Carlos to supervise the rebuilding. The foundation and walls were rebuilt, and the original roof was returned to its position. Although Carlos Call and his local carpenters increased the building's structural integrity, the chapel's original appearance was altered during the remodel.

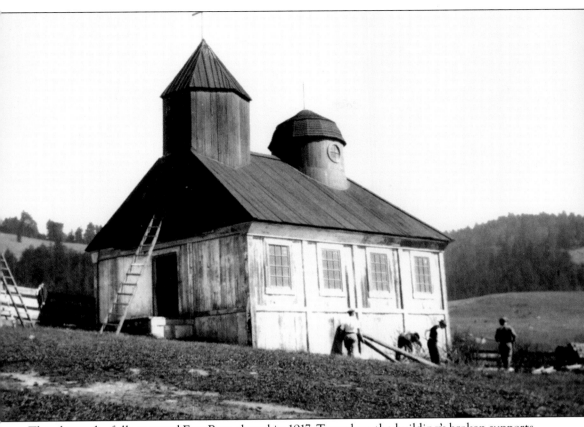

This shows the fully restored Fort Ross chapel in 1917. To replace the building's broken supports, original Russian-cut timbers and planks were taken from the officials' quarters. Carpenters decided to add an extra wall stud to compensate for damage sustained by the ceiling joists and roof beams, which increased the number of windows from three to four. The alterations produced by the 1916 reconstruction remained for nearly 40 years.

William Turk was the first state park employee and "custodian" at Fort Ross. He and his wife Eliese lived at Fort Ross from 1930 to 1939.

Eliese Johanna Kaiser Turk was the sister of Kate Call, Carlos Call's wife.

The Turk House stood next to the Call House. It was the home of G.W. Call's nephews from 1873 to 1878, and was then the home of the Call ranch foreman, John Daily, from 1878 to 1898. Carlos A. Call and his wife Kate lived there from 1904 until 1930 when she died; the Turks lived there in the 1930s. It was razed by the state in 1962, and this area is now a picnic ground adjacent to the Call House. (Courtesy of the Stafford Collection.)

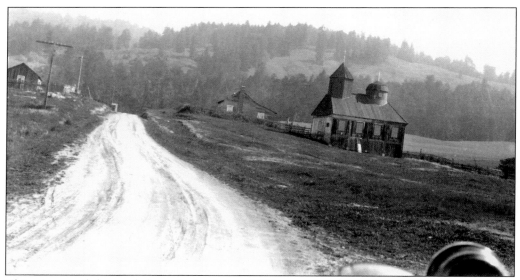

This picture of the road through the fort c. 1934 was taken by a photographer from the *San Francisco Examiner* newspaper.

A Russian Orthodox group visited the chapel at Fort Ross in July of 1933. The congregation includes Father Kashevarov, a descendant of a Russian American Creole.

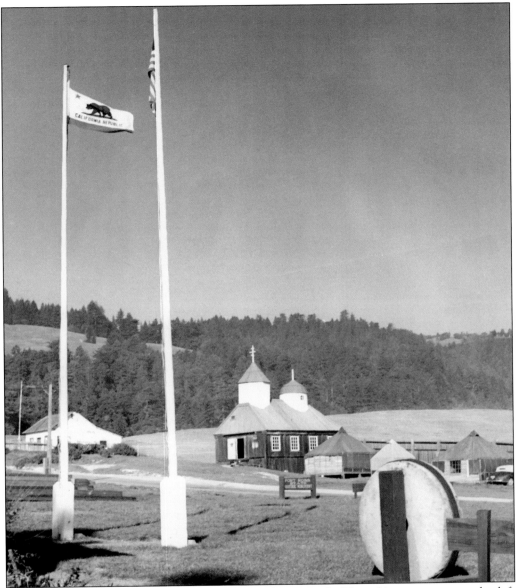

By 1945, the fort interior looks like a traditional state park. The white structure on the left provided housing for park staff, including Ranger John McKenzie. This house also provided accommodations for the U.S. Coast Guard, stationed at Fort Ross from 1942 to 1945 to keep watch for enemy vessels on the Pacific. The tents on the right provided temporary accommodations for construction workers building the fence.

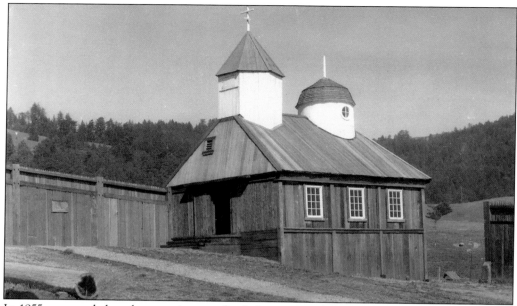

In 1955, a second chapel restoration was funded to restore the structure to the original Russian three-window configuration. From 1948 through the 1960s John McKenzie, state park curator, painstakingly recorded the original Russian structural elements and initiated restoration of the old Russian buildings.

When the Russians departed Fort Ross in 1841, they left one large bell, a candelabrum, candlestand, and lectern, all of which were destroyed in a 1970 fire. Ranger John McKenzie is holding the old Russian candlestand.

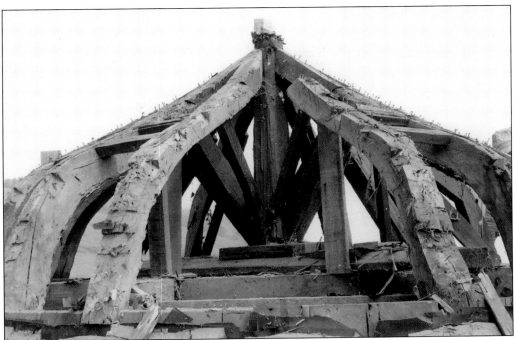

The chapel received a new roof in 1956. Here the original Russian rafters are unveiled to show that the Fort Ross Chapel roof was built with an onion-shaped dome similar to chapels in Russian-Alaska and Russia, although its current construction does not reflect this.

Highway One still divided the stockade on October 5, 1970, when the restored Russian chapel was destroyed in an accidental fire that swept through the building, leaving nothing but a few charred timbers. Supporters of Fort Ross organized the third rebuilding of the chapel with funds obtained from local residents, Russian-American groups, and government agencies. This 1973 reconstruction still stands today. The bell that now hangs outside the chapel was recast using materials from the original bell.

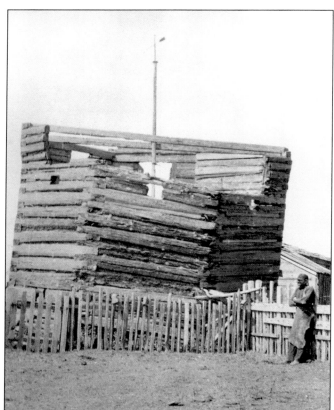

The eight-sided South Blockhouse is pictured here before 1906 with Danish resident and blacksmith Jorgen Peter Hanson.

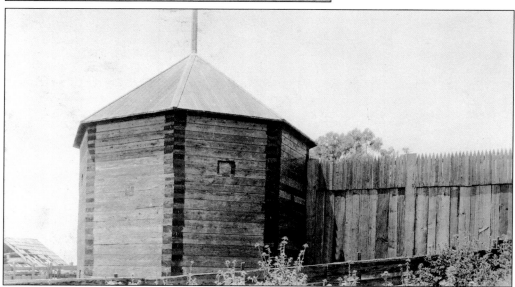

In 1925, the state appropriated $2,500 to rebuild the stockade and south blockhouse and repair the Rotchev House, but work did not commence until 1930. Original floor boards from the officials' quarters were set in the eight-sided blockhouse floor and are still in place. In 1956 and 1957, the south blockhouse was again repaired.

The northwest blockhouse is shown here in 1924.

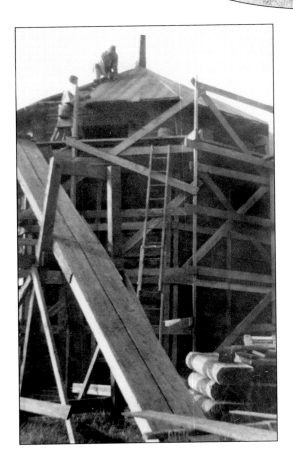

In 1948, ruins of the northwest blockhouse were removed. It was reconstructed in 1950 and 1951 using Russian joinery techniques.

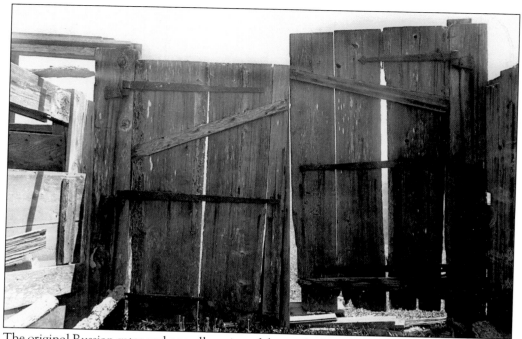

The original Russian gates and a small section of the stockade are shown here in 1912. Each gate measures 4 feet by 10 feet.

Baron Ferdinand von Wrangell's 1834 report describes the Russian stockade: "Set upon a hill with a sharp descent to the sea, and upon a smooth, clayish terrain, the wooden stockade is shaped in a rather large square, which forms four right angles. In two corners, diagonally opposed to each other and connected to the stockade walls, two watch towers have been erected with guns that protect all sides of this so-called fort . . ." Photographs from the ranch era show very little of the original stockade standing. After the fort became a state park, the stockade walls were restored one section at a time. Pictured here is the stockade reconstruction in 1958. In 1972, Highway One was rerouted to bypass the fort, and in 1974 the stockade was fully rebuilt, enclosing the fort as it had during the Russian occupation.

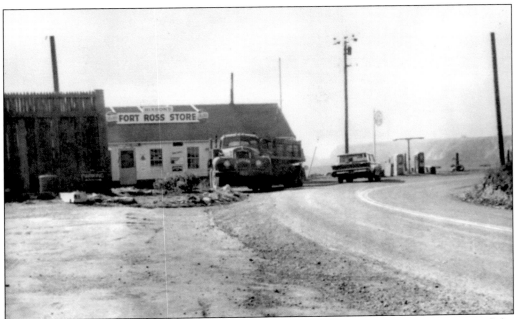

The Fort Ross Store, originally built in 1870, stood just outside the southern entrance of the fort. This picture was taken in 1963 just before it was moved to its present location, two miles north of the fort on Highway One.

This truck barely makes it into the enclosed fort compound during the 1978 reconstruction of the officials' quarters.

The Rotchev House was built *c.* 1836 for Alexander Rotchev, the last administrator of Settlement Ross. It is the only surviving structure that contains construction techniques dating back to the Russian era. The 1841 *Inventory for Mr. Sutter* lists it as, "The new house for the commandant, built of square beams, 8 sazhens long by 4 wide. There are 6 rooms and a vestibule." After the Russians departed, Benitz took up residence in the building and enlarged the house by constructing a two-story addition and front porch. The house continued to be used as a residence by successive landowners, and eventually became the Fort Ross Hotel. By the early 20th century, the building was beginning to fall into ruin. It is shown here after 1916 and prior to the removal of the two-story addition.

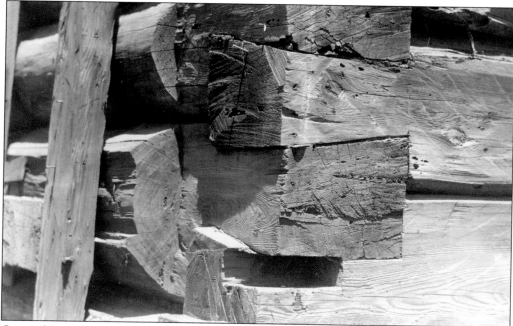

Original Russian joinery detail in the Rotchev House.

This photograph, taken in 1912, shows the fireplace and a portion of Rotchev House interior just prior to its first restoration. The wallpaper, and possibly the fireplace, date from the Benitz period.

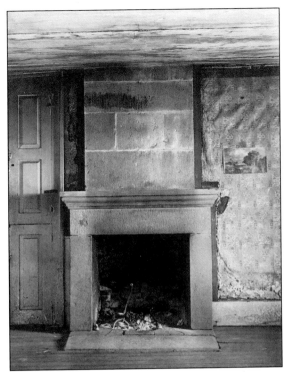

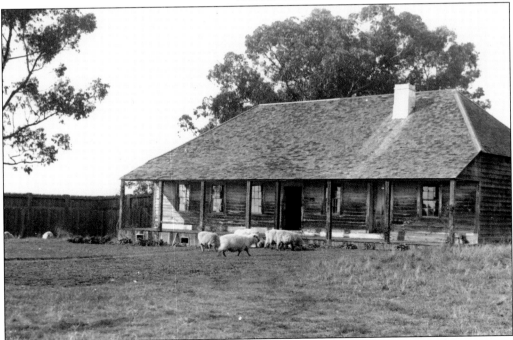

Beginning in 1925, steps were taken to restore the Rotchev House to its original Russian-era appearance. It received a new foundation and a new shingled and gabled roof. The kitchen and two-storied addition were removed in 1926, but the ranch-era front porch is still present.

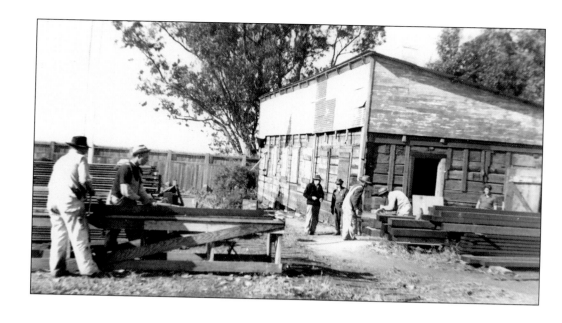

The Rotchev House stands ready for a new foundation and roof in 1942, but work was put on hold until after World War II. Repairs and modifications were completed after the war. The front porch was removed in 1945, a Russian-style hipped roof replaced the gabled roof in 1948, and new windows and concrete piers were added shortly thereafter.

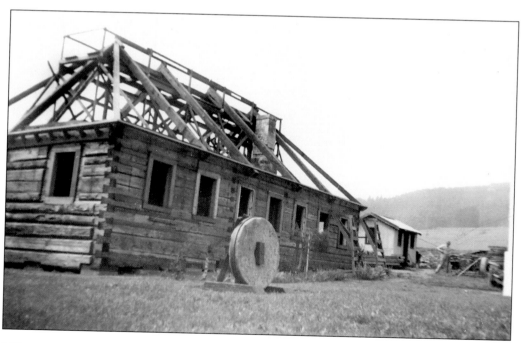

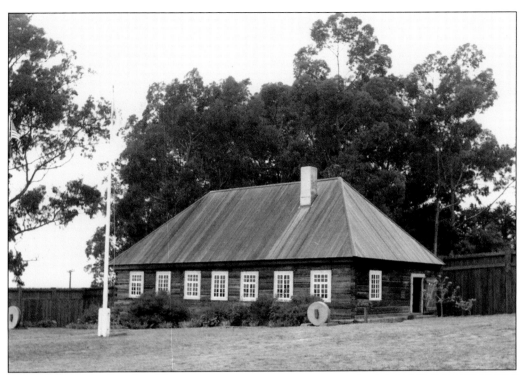

Restoration of the Rotchev House was completed in 1948. It is shown here in a 1960s photograph.

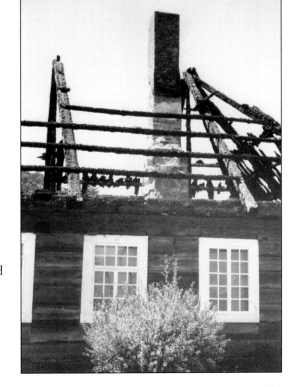

In 1971, a few months after the chapel burned to the ground, an arson fire burned the roof of the Rotchev House. At that time the building was being used as the Fort Ross Museum, and many artifacts stored in the attic were damaged or lost. A hipped roof was constructed from new materials, and the Rotchev House was reopened to the public in 1974.

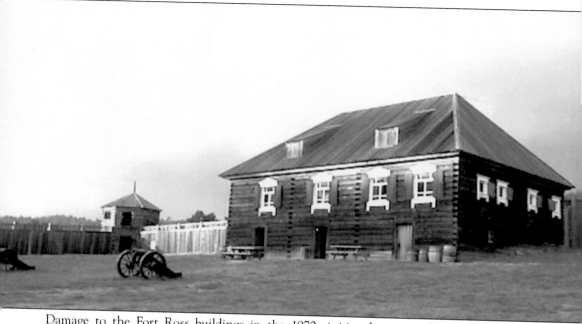

Damage to the Fort Ross buildings in the 1970s initiated an era of reconstruction which produced the fort seen today. The Kuskov House was reconstructed in 1983. This building must have been one of the first Russian buildings to be lost, as there are no pictures or reports of it during the ranching years. It served as headquarters for Ivan Kuskov, the first administrator of Fort Ross. In 1832 an anonymous Bostonian describes it as follows: "The first room we entered was the armory, containing many muskets, ranged in neat order; hence we passed into the chief room of the house, which is used as a dining room & in which all business is transacted. It was comfortably, though not elegantly furnished, and the walls were adorned with engravings of Nicholas I, Duke Constantine . . ."

*Eight*

# FORT ROSS
## THE 21ST CENTURY

By the end of the 20th century Fort Ross State Historic Park had been expanded to 3,200 acres, including some of the most pristine and dramatic coastline in California. Although the original Russian stockade became a California state park in 1906, it was not until 1962 and 1976 that the state purchased additional acreage, including the old Russian orchard, the Call dairy on the hillside, and the coastal terraces surrounding the stockade. In 1990 the state, in conjunction with the Save-the-Redwoods League, acquired another 2,157 acres, including old-growth redwoods, open meadows, oak woodlands, and Kolmer Gulch Beach. The park now reaches as far as Seaview Road at the top of the ridge, and for a mile in each direction from the fort along the coast. Much of this land was the original Call Ranch property which had been sold to logging interests. Tourism, which began in the Fort Ross Hotel days, has expanded to a yearly total of some 150,000 visitors coming from all over the country and beyond.

In the 21st century Fort Ross is a state historic park as well as a site of international importance. Many contemporary Russian and Russian-American visitors consider it to be a vital symbolic link between the two countries. In recent years the fort has been visited by the Patriarch of the Orthodox Church Aleksy II, the speaker of the Russian senate, the Russian ambassador to the United States, and by the "peace generals," a joint visit by the United States Air Force chief of staff and his four-star Russian counterpart. Scholars and historians now work together in an international exchange, which contributes to more accurate preservation and interpretation of the Russian settlement.

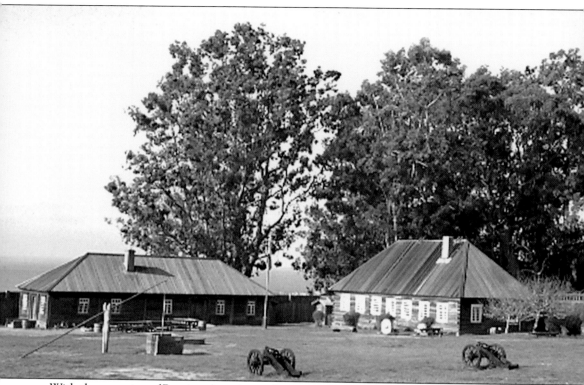

With the warming of Russian-American relations in the 1990s, Fort Ross became a focal point for Russian and American scholars. This international exchange of knowledge will help increase the authenticity of future restoration efforts at Fort Ross. The ongoing preservation and furnishing of the Rotchev House (right), the sole Russian-built structure which has survived, will greatly benefit from original source materials and the expertise of Russian architects and historians.

Archaeologists continually enrich our knowledge of the park's history and pre-history. This Native-Alaskan village site is situated on the marine terrace in front of the stockade walls. The one-half acre archaeological site was investigated by archaeologists from state parks and the University of California, Berkeley, in the summers of 1989, 1991, and 1992.

In 1990, archaeologists from the University of Wisconsin, Milwaukee, and from California State Parks investigated the boundaries and composition of the historic Russian cemetery. Although researchers identified a lengthy list of people who died at Fort Ross, the names associated with the 131 burials are not known. The artifacts recovered—dishes, beads, buttons, cloth fragments, and religious medals—will help researchers better understand the Russian settlement's culture. (Courtesy of Sannie Osborne.)

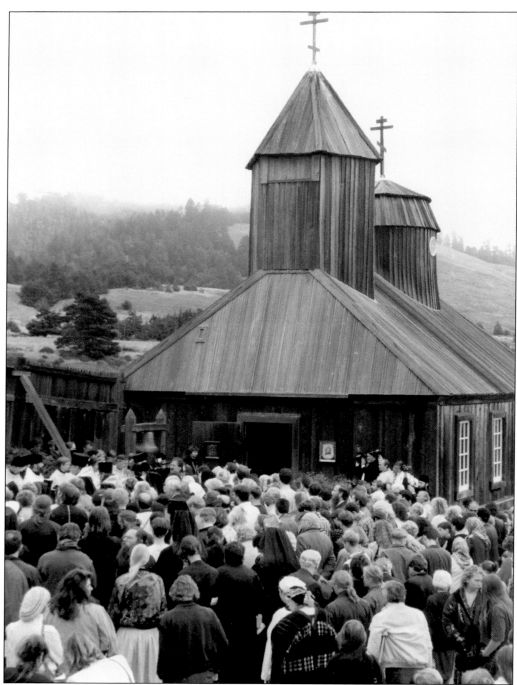

Members of the Russian Orthodox Church in both America and Russia consider Fort Ross to be a special place. Congregations continue the tradition begun early in the 20th century of holding services in the Fort Ross chapel, the first Orthodox chapel in the continental United States, on Memorial Day and July Fourth of each year. Occasionally services are held for other occasions, such as in this photograph when Patriarch Aleksy II visited California in 1993.

Great changes in the Russian government in the 1990s have brought unprecedented numbers of Russian scholars, church officials, politicians, and ordinary citizens to Fort Ross. The great-great grandson of Saint Innocent visited Fort Ross in 1989. He is pictured here with Fort Ross Ranger William Walton and former Ranger John McKenzie in the background.

A dramatic though uncommon site was the arrival of three helicopters to transport visiting Russian and American "top brass" back to civilization in 1992. "It was outrageously costly from a person's point of view. But it was streaks ahead of paying for missiles, satellites, silos, standing armies, and fear." (Photo and quote by John Sperry.)

Over 6,000 children visit Fort Ross on school field trips each year. In the Environmental Living Program, fourth-grade schoolchildren participate in an overnight living history experience. Hundreds of California schools send students to experience life as it might have been for children at this Russian colonial settlement.

The annual Cultural Heritage Day is held each summer on the last Saturday in July. Up to 100 volunteers and park staff dressed in period costume portray activities that might have taken place at Fort Ross when it was a Russian settlement. Thousands of visitors from all over California attend and are encouraged to participate in Russian dancing, rope making, and basket making.

The cannons at Fort Ross were used to salute ships and important visitors, but were never fired in battle. Today they greet school groups and visiting dignitaries, and lighting the cannons provides much excitement during Cultural Heritage Day.

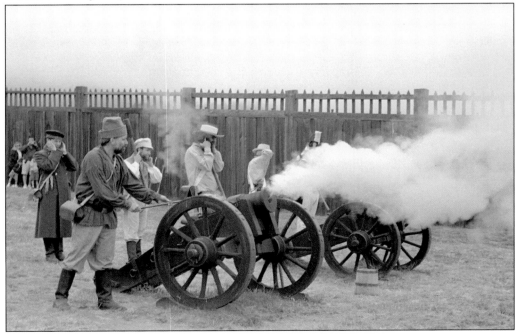

Over the last decade, members of the local community have rallied to preserve the historic Call ranch house at Fort Ross. It is now in sound condition, its interior furnished with turn-of-the-century household items. The Call House is open to the public the first weekend of each month.

The garden is again flourishing as it did when Mercedes Call cared for her flowers. Volunteer gardeners such as Lynn Rudy (local ranch-era historian) and Barbara Black (granddaughter of George W. and Mercedes Call) meet each Monday to tend this historic garden.

# *Nine*

# JENNER TO GUALALA
## A WIDESPREAD COMMUNITY

The Sonoma coast is home to a diverse group of people that come here for many reasons. Ranchers, farmers, retirees, artisans, craftsmen, and professionals all settle here. Once settled, most stay. These Sonoma coast residents have much in common with the ranch-era settlers that came before. They tend to be hardy, independent, and deeply proprietary of the land. Not unlike when the coast road was first proposed, locals are still concerned that the outside world "will be in on us" and spoil our secret. Over the last 50 years several large ranches have been subdivided, and houses now dot the hills on Muniz Ranch and Timber Cove. Farther north, The Sea Ranch, a private planned community designed with an eye towards environmental sensitivity, now extends for 10 miles along the northern edge of the Sonoma Coast. Although weekend visitation has increased, vast stretches of the coast are remarkably unchanged from centuries past. Maybe it's the severe winter weather—and the periodic power outages and road closures the weather causes—that keeps the population down. Whatever the cause, the coast, a mere 75 miles north of the bustling Bay Area, is still a quiet and peaceful place.

State and county parks have acquired vast holdings along the coast, helping to ensure that the landscape will remain pristine. Several of the ranch-era townships are now parkland, and yet this preservation has been at the expense of the community centers which thrived in the past. But today's residents and tourists can now enjoy phenomenal public lands up and down the wild Sonoma Coast, with access to hiking, whale watching, and a wide variety of recreational activities.

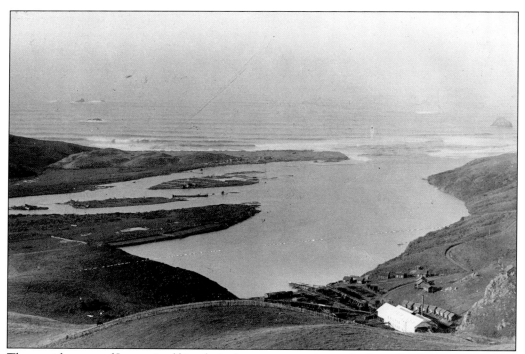

The seaside town of Jenner itself is relatively recent; postal records show that Jenner began mail service in 1904, around the time this picture was taken. Jenner, Goat Rock Beach, Penny Island, Willow Creek, and the surrounding landscape exist much unchanged as state park land today through the efforts of residents who formed the Jenner Coastside Conservation Coalition in 1970. This organization worked actively to save this area from massive dredging (Penny Island was to be removed and its gravel sent to San Francisco) and large-scale development. Longtime Jenner resident and past postmistress Elinor Twohy (below) was instrumental in this movement. She has also observed and recorded the sea mammals at Goat Rock beach every day for over a decade, charting their behavior and identifying the mix of harbor seals, sea lions, and the occasional elephant seal that hauls itself out on the beach. (Courtesy of Elinor Twohy.)

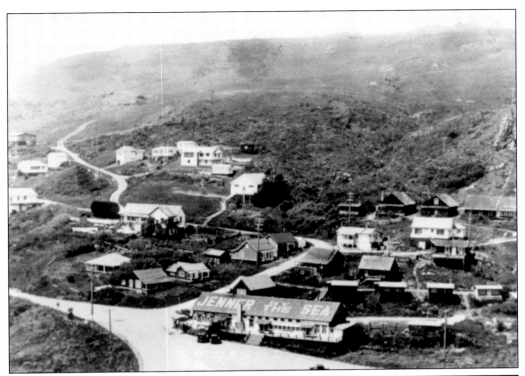

Jenner and the Russian River estuary are often called the gateway to the north coast. With cars came tourism, as Jenner became popular with city folk who enjoyed the scenic meeting of river and ocean. This picture was taken between 1934 and 1938 and shows the expanded seaside town. (Courtesy of Elinor Twohy.)

The Jenner School was started for the children of the mill workers. It was a community effort all around, with Jenner residents volunteering to build the school using lumber donated by the A.B. Davis Lumber Company on land donated by Charles Rule. The school's final class of 1969 graduated one student. The Jenner school was the largest of the one-room school houses still visible on the Sonoma North Coast, and was also used as a community center. (Courtesy of Elinor Twohy.)

The Pyramid, shown here during its construction in the early 1970s, is a well-known landmark located just north of Jenner on Muniz Ranch. It is described in a real estate flyer: "The Pyramid is no mere building—it is truly a Temple! It is a source of beauty and inspiration to all who experience it. The construction of The Pyramid is to the specifications, scaled down, of the 'Great Pyramid' of Egypt."

When Fort Ross became a state park, the community infrastructure that once surrounded the fort was moved to the ridge above. The new centers of community activity are now Fort Ross School, and the neighboring Timber Cove Volunteer Fire Department, both designed by architect, long-time resident, and fire chief Michael "Zippy" Singer. (Courtesy of Sarjan Holt.)

Residents in remote areas depend on dedicated volunteers to staff the fire departments along the coast for immediate response to any emergency. The firefighters, such as those shown above, train every Wednesday evening at the Timber Cove Firehouse; their group photo below was taken in front of a historic house at Plantation during the annual fire department fundraising event, a Mother's Day breakfast that is well-attended by the community. (Courtesy of Philip Barlow.)

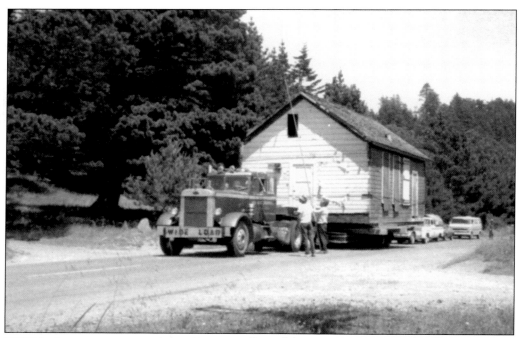

One of the most intriguing and well preserved of the old coastal school houses is the original Fort Ross School. Although originally built at Fort Ross, this school was moved to the ridge to follow the school population. In 1973, when no longer needed on the ridge, community members moved the school again (for the fourth time in its history) to its present location at Stillwater Cove Regional Park. The fully-restored school may be visited by walking a short distance through the park's pristine coastal forest. A new Fort Ross School was rebuilt on Seaview Ridge Road, and currently provides schooling for approximately 60 children. These days it is the only school on the coast between Jenner and Point Arena. (Courtesy of Stillwater Cove Regional Park.)

A few miles north of Stillwater Cove, Salt Point State Park preserves a wide swath of the Sonoma coast. Sawmills, lumber chutes, and stone quarry operations have long since disappeared, but on the marine terrace north of Gerstle Cove, chunks of quarried stone left behind remind us of the once-thriving industries in this area. Hikers may happen upon this obelisk near Fisk Mill which marks the graves of Andrew Fisk and his infant daughter Clara Belle, who died in the summer of 1874.

Just north of Salt Point is the historic Stewarts Point Store, established in 1868. Four generations of the Richardson family have run the store since 1881. Archer J. Richardson, who waited on his first customer when he was six, is turning the store over to his cousins in 2004. Today Stewarts Point is largely unchanged from 1930 when this picture was taken. A.H. Richardson was the proprietor, and the gasoline was distributed by Shell. Now a Chevron sign hangs on the building.

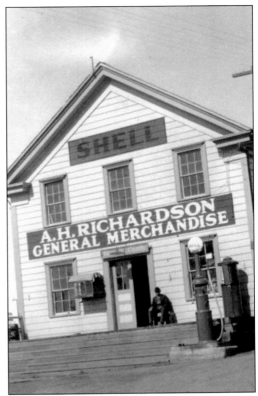

The Sea Ranch chapel is a "non-denominational chapel for individual prayer and meditation" designed by architects Hubbell and Hubbell, and built by some of the many artists who have made the North Coast their home. The curves of the roof were extremely difficult to accomplish, and the builder, Tambe Kumaran, drew from his boat-building experience to achieve the sweeping roofline that is reminiscent of wings, or perhaps a powerful ocean wave. The building's naturalistic materials are emblematic of The Sea Ranch architecture.

# REFERENCES AND BIBLIOGRAPHY

This is a partial listing; please contact the authors for details.

Alekseev, A.I. *The Odyssey of a Russian Scientist: I.G. Voznesenskii in Alaska, California and Siberia*. Edited by R.A. Pierce. Translated by Wilma C. Follette. Fairbanks, Alaska: The Limestone Press, 1988.

Carr, Laura Call. *My Life at Fort Ross*. Fort Ross Interpretive Association: 2004.

Chamisso, Adelbert von. *A Voyage Around the World with the Romanzov Exploring Expedition in the Years 1815–1818 in the Brig "Rurik," Captain Otto Von Kotzebue*. Translated and edited by Henry Kratz. Honolulu: University of Hawaii Press, 1986.

Dmytryshyn, Basil; E.A.P. Crownhart-Vaughn; Thomas Vaughn, ed. *The Russian-American Colonies: 1768–1867*. Oregon: Oregon Historical Society Press. 1989.

Duhaut-Cilly, Auguste. *A Voyage to California, the Sandwich Islands, & Around the World in the Years 1826–1829*. Translated and edited by August Frugé and Neal Harlow. Berkeley: University of California Press, 1999.

Fort Ross Interpretive Association. *Fort Ross Interpretive Association Newsletter* Fort Ross, California: 1988–2004.

Golovnin, Vasilii M. *Around the World on the Kamchatka 1817–1819*. Translated by Ella Lury Wiswell. Honolulu: University of Hawaii Press, 1979.

Istomin, Alexei A. *The Indians at the Ross Settlement: According to the Censuses by Kuskov, 1820–1821*. Fort Ross, California: Fort Ross Interpretive Association, 1992.

Kalani, Lyn; Lynn Rudy; John Sperry, editors. *Fort Ross*. Fort Ross Interpretive Association: 2001.

Khlebnikov, K.T. *Colonial Russian America Reports, 1817–1832*. Translated by Basil Dmytryshyn & E.A.P. Crownhart-Vaughn. Portland: Oregon Historical Society, 1976.

Khlebnikov, K.T. *The Khlebnikov Archive: Unpublished Journal (1800–1837) and Travel Notes (1820, 1822, and 1824)*. Edited by Leonid Shur. Translated by John Bisk. The Rasmuson Library Historical Translation Series, Vol. V. Alaska: University of Alaska Press, 1990.

Lightfoot, Kent G.; Thomas A. Wake; Ann M. Schiff. *The Archaeology and Ethnohistory of Fort Ross, California*. Vol. 1. Number 49. Berkeley: University of California Archaeological Research Facility, 1991.

Ogden, Adele. *The California Sea Otter Trade 1784–1848*. Berkeley: University of California Press, 1941.

Pierce, Richard A. *Russian America: A Biographical Dictionary*. Fairbanks, Alaska: The Limestone Press, 1990.

Smith, Barbara Sweetland. *Science Under Sail: Russia's Great Voyages to America 1728–1867*. Anchorage, Alaska: Anchorage Museum of History and Art, 2000.

Smith, Barbara Sweetland & Redmond J. Barnett, editors. *Russian America: The Forgotten Frontier*. Washington: Washington State Historical Society, 1990.

Veniaminov, Ioann. *Journals of the Priest Ioann Veniaminov in Alaska 1823 to 1836*. Translated by Jerome Kisslinger. The Rasmuson Library Historical Translation Series, Vol. VII. Fairbanks, Alaska: University of Alaska Press, 1993.

Watrous, Stephen, compiler and translator. *Portraits of Prominent Russians—Managers at Ross* and *Founder of Fort Ross—Ivan Kuskov*. Lecture notes, Fort Ross: 1990s.

Wrangell, Ferdinand Petrovich. *Russian America Statistical and Ethnographic Information*. Edited by Richard A. Pierce. Translated by Mary Sadouski. Kingston, Ontario: The Limestone Press, 1980.